...ut the
...thors

DENISE JOYCE (in red) is a longtime editor for the *Chicago Tribune* and has the gold watch to prove it. She and her husband have two grown children; their behavior supports the theory that one out of every two children is terrified of Santa—and clowns.

NANCY WATKINS is a *Chicago Tribune* features editor and writer who is much too good a mom to have ever forced her son, now 11, to sit on Santa's lap.

Courtesy of The 900 Shops, Chicago

Scared of Santa

SCENES OF TERROR IN TOYLAND

DENISE JOYCE AND NANCY WATKINS

HARPER

NEW YORK · LONDON · TORONTO · SYDNEY

HARPER

HarperCollins books may be purchased for educational, business, or sales promotional use. For information please write: Special Markets Department, HarperCollins Publishers, 10 East 53rd Street, New York, NY 10022.

Designed by Timothy Shaner, Nightanddaydesign.biz

Library of Congress Cataloging-in-Publication Data is available upon request.

ISBN 978-0-06-149099-6

08 09 10 11 12 RRD 10 9 8 7 6 5 4 3 2

Contents

Contents

Contents

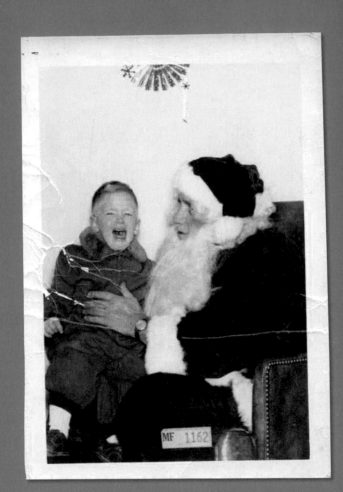

"There, there, Mommy will be back soon from happy hour."
Cindy Crawford of Palos Hills, Illinois, sent this one of her brother
Jim, circa 1958.

Introduction

DO YOU HEAR WHAT WE HEAR? Jingle bells jingling, Christmas carols playing, and sweet little children screaming their lungs out as their camera-toting parents haul them up onto Santa's lap.

In 2003 and 2006, the *Chicago Tribune*'s "Q" section asked readers to send in their favorite pictures of frightened children with Santa. The result: hundreds of photos starring teary-eyed children and mostly resolutely cheerful Santas. We also received scores of photos featuring children looking more startled than scared, not to mention worried, annoyed, or simply bored. We got pictures of howling triplets, toddlers wriggling right out of their clothes, and kids trying to flee in all directions.

As for Santa, he ranged from a right jolly old elf to a dodgy-looking character who made you wonder what, exactly, he might be packin' in that suspiciously bulging bag.

Our get-me-outta-here gallery was posted on the *Tribune*'s Web site (chicagotribune.com/scaredofsanta), cheerfully running up page views just beyond 850,000. And the best ones were featured in the *Tribune*'s "Q" section.

But this was not strictly a stroll down misery lane. We learned a few things, too, that we invite any psychologists out there to procure a lucrative grant to study further:

- Twin boys are much more likely to be scared of Santa than are twin girls.

- Dressing children in cute holiday outfits does not make their screaming look any more festive.

- Given the appearance of some Santas, especially the vintage ones—the ones we call the Old Testament Santas, as opposed to the modern, jolly New Testament versions—kids have good reason to be afraid.

- Modern Santas are more likely than their decades-ago counterparts to wear white gloves. Perhaps the gloves help them maintain their grip on the kids. Or maybe they just don't want to leave fingerprints.

- Whatever they pay Santa, it isn't enough.

Speaking on behalf of the cheerful Santas, Nicholas Trolli of Philadelphia, president of the Amalgamated Order of Real Bearded Santas, says he and his brethren would much rather have kids happy as they clamber onto Santa's lap. To avoid the waterworks, Trolli offers parents this advice: As you approach, hug your child close, with the child facing away from Santa. Ease into the big meeting by sitting on Santa's knee, still holding your child. A good Santa has excellent helper elves, Trolli says, and they all will work with you to make the experience a pleasant one.

Fortunately for us, there were enough clueless parents out there to provide plenty of screaming children for this book. Still, we feel the public service announcement about maintaining peace might keep us on Santa's nice list.

Despite all the weeping and wailing, there doesn't appear to be any long-term psychic damage that can result from a trip to see Santa. As Exhibit A, we offer Roman Sikorski of Waukesha, Wisconsin, a well-adjusted

father of two adult children. In 2003 he submitted a picture, circa 1949, of himself and assorted family members lined up in rigid terror while a creepy sort of fun-house Santa lurked in the background. (See page 261.)

Not for Roman a mere few seconds of horror on Santa's lap: "The dread would begin days before. My stomach would churn—and not from butterflies of happy anticipation. It was fear."

What struck such fright in Roman's heart? It seems that when the extended family gathered to mark the holiday, Santa would make his grand entrance and ask the parents if their children had been good. Every year one aunt and uncle would turn state's evidence on their wild offspring.

"Santa would pull out a razor strap," Roman said. And the naughty cousins would get a good whack or two with the strap. We suspect they would have preferred a lump of coal.

So there you have it. If Roman Sikorski can survive a razor-strap-toting, fun-house-looking Santa and go on to a happy and productive life, a few weepy moments with a jolly Santa offering candy canes as bribery are truly child's play.

Still, we hope we aren't opening any old emotional wounds by compiling all these photos into a book—and we're referring to the poor Santas as much as we are the kids. But if we are, don't come crying to us; take it up with the people who put you on that scary man's lap in the first place.

DENISE JOYCE and NANCY WATKINS

Chapter 1
TITANS OF TEARS

As Elvis is to rock, as Rembrandt is to painting, and as De Mille is to film, these are the classics, the children who help define the very concept of "Scared of Santa." And you thought they just needed a nap.

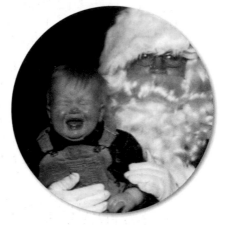

'TWAS THE FRIGHT
BEFORE CHRISTMAS . . .

Tim Sivesind, 2000.
Sent by mom Martha.

"IF I GET HAT HAIR FROM
THIS, SO HELP ME . . ."

Perhaps we can show Elizabeth
Alice Fishman something in a
beret, 2004. Sent by parents
Laura and Ron.

"I HOPE YOU'RE PREPARED TO PAY FOR MY THERAPY SESSIONS, MOM!"

Three years after Katarina Hausman's 2003
visit to Santa, she was still refusing to
go back, according to mom Amy.

IT'S ALWAYS A CHALLENGE TO SUSTAIN THAT HIGH C.

Luke Fuller in full voice in 2006.
Sent by mom Kim.

"I'LL TELL YOU WHO THE SUCKER IS HERE: ME!"

A lollipop does nothing to cheer John Dowling,
with sister Beth in 1961. Sent by mom Margaret.

THE TODDLER WAS SLUNG BY THE CHIMNEY WITH CARE . . .

Christopher Todd, 1990.
Sent by mom Cindy.

"KEEP THIS UP, AND NO REINDEER GAMES FOR YOU."

Santa, Sean Higgins, and Rudolph, 1993. Sean's parents,
Susan and Dan, say, "It's too bad audio can't accompany
[this photo] because there was a silent wail that didn't
come out for a good fifteen seconds."

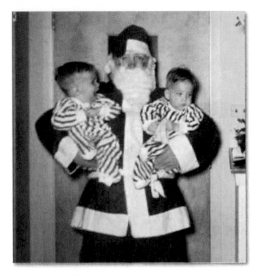

"WHO ORDERED THE TWO-FOR-ONE SPECIAL?"

Bill and Bob Morrow delivered by dad Bill as Santa, 1960.
Sent by sister/daughter Jill Mikolajewski, who now
lives in the same house.

"I'VE GOT A FULL DIAPER AND I'M NOT AFRAID TO USE IT."

For her first visit to Santa in 2005, Zoe
Pramuk fit the "Scared of Santa" profile
perfectly: excited until the moment she
was placed in his lap. And yet, reports
mom Jennifer Baggett-Pramuk, she
came back for more the next year.

"I'VE BEEN BLINDED BY THE TREE!"

Sue Brown Placek sent this one of herself in 1959 with an aluminum tree that posed a challenge today's photographers don't have to face.

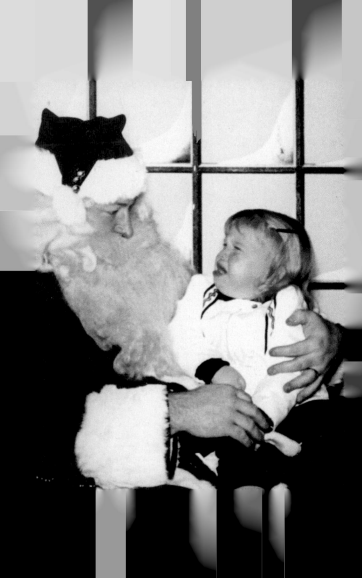

"PLEASE, LET ME KEEP WHAT'S LEFT OF MY DIGNITY."

Reports Susan Falsone of this 1992 shot
of daughter Teresa, "Santa was restraining
her because she was trying to escape."
Way to fight the power, Teresa.

NO! DON'T MAKE EYE CONTACT!

Jan Bryant dares to confront Santa
on her first encounter with him
in 1957. Sent by mom Ann.

12/16/2006

Christmas 2005

DEFINITELY NOT A SANTA BABY.

Lily Rosenau, 2005. Sent by dad.

"SO THIS IS WHAT IT'S LIKE TO BE A CAGED ANIMAL."

Joey Clemente takes a walk on the wild side at Brookfield Zoo outside Chicago in 2006. Sent by mom Debbie.

YOU'VE HEARD OF DROOL BIBS.
WELL, THIS IS A TEAR BIB.

Maybe what Andrew Millard really needs is
a rain poncho, 2002. Sent by dad Bryan.

"AND ON TOP OF IT ALL, I HAVE MORE HAIR RIBBON THAN HAIR!"

Santa had better move his thumb before Isabella Faith Zamora takes a chomp out of it, 2006. Sent by mom Tiffany Robinson.

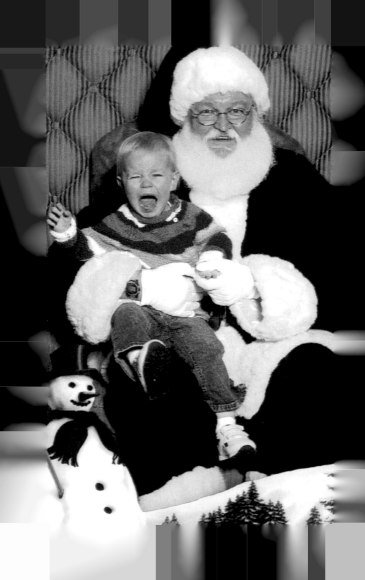

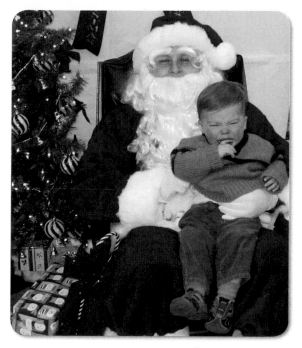

"HEY! IT <u>HURTS</u> TO BITE THAT!"

Emmett Robison adds self-injury to
insult, 2006. Sent by mom Jennifer.

ONE LAP, NO WAITING.

Amy Sauber couldn't believe her good luck when
she was shopping with daughter Kylie the day
after Thanksgiving 2006 and there was no line
to see Santa. Her luck changed quickly.

BOARD UP THE WINDOWS, EMMA. THIS ONE'S A CATEGORY 5.

Trey Slinkman lets out a storm of protest, 2006. Sent by parents Doug and Ashley.

"TELL SANTA TO STOP RUBBING MY HAIR! IT'S ALL STATICKY!"

Charlie Sieg's first visit with Santa in 2005 was a hair-raising experience. Sent by mom Sharon, "the cruel parent" (her words, not ours).

THE CAMOUFLAGE DIDN'T WORK. NEXT TIME, TRY A RED SUIT.

Gustav Tosterud, 2005. Sent by parents Dominic and Karli.

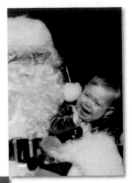

"FAIR JULIET, WHEREFORE ART THOU SO CRABBY? IS IT YONDER POMPOM IN THINE EAR?"

Juliet Thurman feels she's at the center of a Shakespearean tragedy, 2002. Sent by mom Katharine.

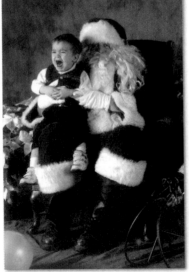

"I SAVED THIS TANTRUM JUST FOR YOU."

Jack Stewart, 2004. Sent by mom Maggie.

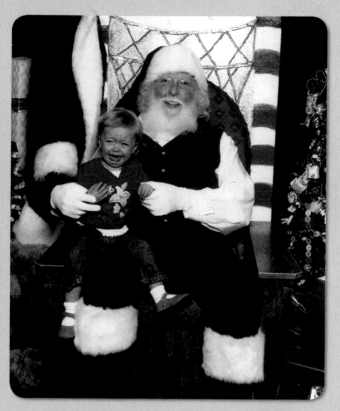

TWO MINUTES THAT WILL LIVE IN INFAMY.

"We waited in line for forty-five minutes and nothing but smiles," writes Chris Shoup of daughter Maggie's 2006 encounter. "Forty-five seconds after, nothing but smiles. The two minutes in between: painful."

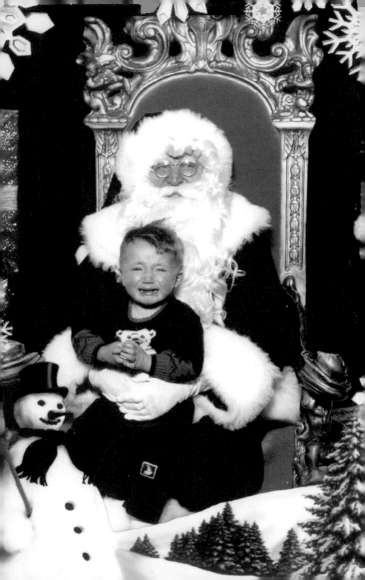

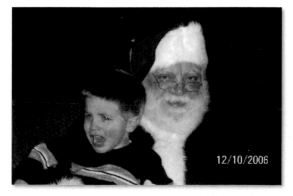

12/10/2006

IF HE'S SCARED NOW, WAIT TILL HE TURNS AROUND.

Josh Herlin, 2006. Sent by mom Christine.

"I'VE LIVED A FULL LIFE. NOW I GUESS IT'S GOOD-BYE."

Stephen Vosburgh is sure it's all over, 2002.
Sent by parents Leslie and Ken.

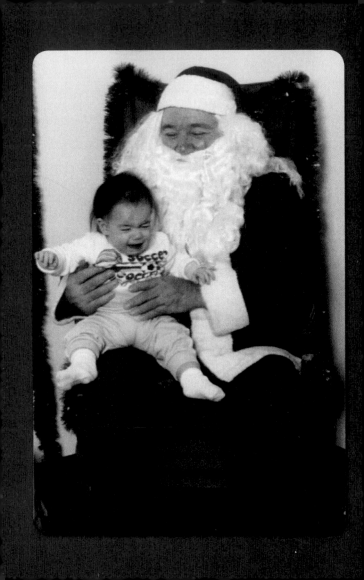

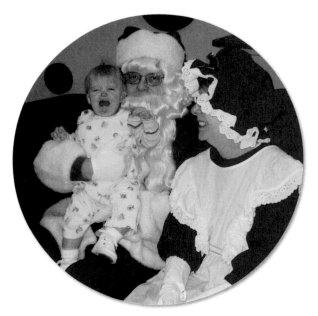

**"HOW DID WE DO IT? TWO
WORDS: FERTILITY DRUGS."**

Christian Nowoj, 2006.
Sent by real mom Michele.

**"LET'S SEE WHAT HAPPENS
IF I SQUEEZE HER AGAIN."**

Renee Tuzak wants no part of
any abdominal palpating, 1987.
Sent by mom Jean.

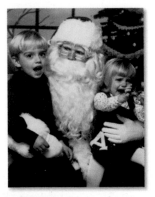

"A" IS FOR ANGUISH.

Kyle and Kristen Martin,
1989. Sent by mom Diane.

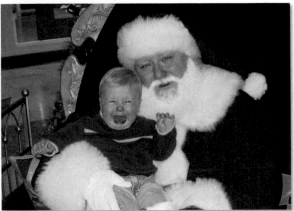

IN THIRTY YEARS HE'LL BE BACK, CARRYING A LAW DEGREE AND A GRUDGE.

Aidan Valentine is ticked off and taking
names, 2006. Sent by dad Matt.

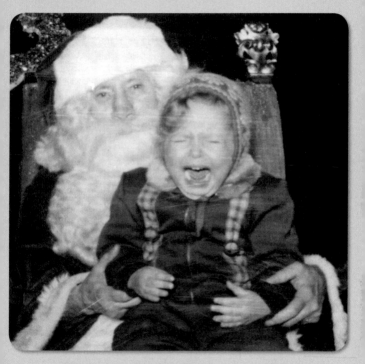

"BETTER NOT POUT? YOU'RE GONNA <u>BEG</u> ME TO POUT BY THE TIME I'M THROUGH."

Elise Wanda, 1956. Sent by mom Margaret.

Chapter 2

SANTA HAS FEELINGS, TOO

Santa Claus is a guy who wears his heart on his big red sleeve, and usually he lives up to his jolly reputation. But even Santa has his days.

You can't blame the guy. If you never knew whether your clients were going to be happy to see you or burst into tears at the very sight of you—you lawyers know what we're talking about—it might start to show in your countenance too.

"MY . . . KNEE . . . IS . . . WET."

Jacki Alberts, 1998. Sent by mom Judy.

"GOOD GOD, SHE'S RIGHT. I <u>AM</u> SCARY!"

This is what Jamie Azara got for waiting an hour
to see Santa in 2006: a screaming, sobbing
Ava and an apprehensive old elf.

"SCREAM LOUDER, HE'S STILL ASLEEP."

Cassie Khan's elapsed time on Santa's lap was twelve seconds, according to mom Shila. That's big brother Alex waiting her out in this 2006 photo.

"NO COP WILL SHOOT A KID ON CRUTCHES."

"I don't remember that day, but I do remember my cool red coat and hat," says Denise Issert, who sent this 1963 photo taken with brother Stephen.

"OK, ELVES, I'LL GIVE YOU A RAISE—JUST GET ME OUT OF THIS."

Madelyn Guthrie with Santa and a couple of indifferent elves, 2000. Says mom Maria, "I got lots of grief from *my* mom when she saw this picture: 'How could you?'"

IT DOESN'T GET ANY BETTER THAN THIS, DOES IT, SANTA?

Jeudi Chilson couldn't stop laughing as this photo of August was being taken in 2006: "I'm sure they thought I was the meanest mother in the world." Actually, they were probably distracted by the meanest-looking Santa in the world.

"DO YOU KNOW HOW TO SHUT HIM OFF?"

Kevin Nelson's grandparents decided to surprise his parents by taking him on his first visit to Santa, 2005. What a shame that they couldn't share this precious moment. Sent by grandma Alison McNutt.

"I WILL LIFT UP MY EYES TO THE HILLS, FROM WHENCE COMES MY HELP."

Twins Bryn (left) and Alex Philiotis at age 23 months with a Santa who has aged 23 months just since they arrived, 1999. Sent by mom Barbara.

WE'VE HEARD OF LAUGHTER BEING CONTAGIOUS, BUT THIS?

Twins Nicholas and Madison Precht, 2002. Sent by mom Stacie.

A SCREAM SO LOUD IT'LL KNOCK YOUR BEARD OFF.

Clara Thurm exposes her tonsils
as Santa nearly exposes his face
in 2006. Sent by parents
Jeremy and Larke.

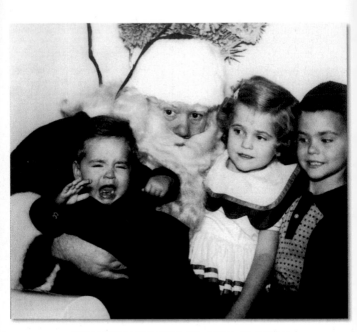

"HIDE ME! IT'S THE EX—MRS. CLAUS."

Chuckie (left), Tammie, and Tim Weber, 1953.
Sent by Tammie Sivesind.

**"I MAKE THEM LAUGH, I MAKE
THEM CRY . . . BUT WHO WILL
MAKE ME LAUGH?"**

Donna Saraga, representing comedy, and
daughter Jessica, representing tragedy, 1983.

"IF I SIT VERY, VERY STILL, MAYBE THEY'LL FORGET I'M HERE."

Santa looks almost inconspicuous next to Quinn Gresko, Austin Boos (holding Quinn), Shelby Boos, Nick Gresko (held by Shelby), and Alex Gresko, 2006. Sent by grandma Linda Nicholson.

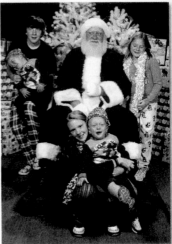

NEVER LET 'EM SEE HOW SCARED YOU ARE.

Calla Williams with a Santa (a.k.a. Uncle Don) who's clearly in over his head, 2004. Sent by mom Lisa.

"MO-OM, WHY CAN'T
I HAVE SUCH BIG,
BOUNCY CURLS?"

Ella Vick, 2006. Sent by
parents Kimberly and
Lawrence.

WHEN YOU'VE HAD THE SAME JOB FOR A FEW HUNDRED YEARS, ENNUI IS BOUND TO SET IN.

Brianna Bliss in 1996 with a Santa who "looks like he's getting ready to push her off," according to parents Mark and Michelle.

THAT'S RIGHT, HOLD TIGHT TO THAT PURSE. HE'S JUST PRETENDING TO IGNORE YOU.

Janine Davis knows how to deal with pickpockets, circa 1967.

Chapter 3

NAVEL MANEUVERS

Like a wolf caught in a trap, some children have such an overwhelming need to be free that they will leave behind whatever they must, including their clothing.

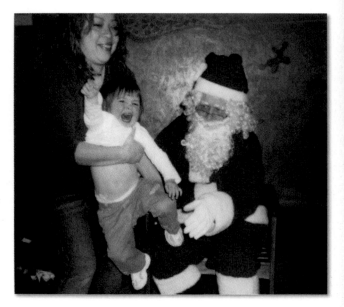

SO-O CLOSE TO A CLEAN GETAWAY.

Lily McManamy strains to escape, either aided or hindered
by her day-care teacher—no one is quite sure, 2005.
Sent by parents Sean and Melissa.

THIS WAS BRIAN'S SECOND BIRTHDAY. NEXT ON THE AGENDA: A CAKE MADE FROM BRUSSELS SPROUTS.

Santa even sang "Happy Birthday" to him, but there were no happy returns for Brian Heidegger, 1998. Sent by parents Mike and Margaret.

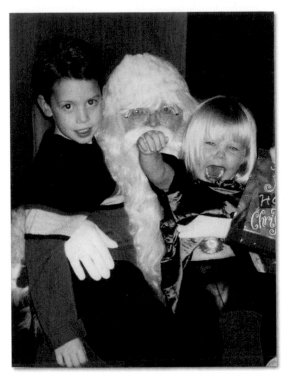

**"NEVERMINDYOUDON'THAVETOGET
MEANYTHINGGOODBYE!"**

Zack and Ariel Sanders, 2000. Sent by mom Kim.

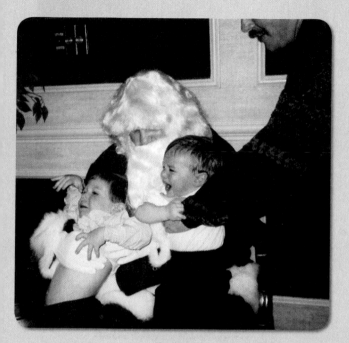

STEP 1: SLIP OFF THE LAP.
STEP 2: SLIDE OUT OF THE SHIRT.

Clark (left) and Paddy McNally have a
system, 1994. Sent by mom Sarah.

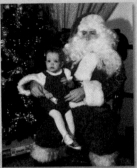

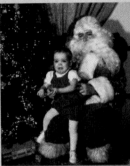

SANTA, MASTER OF THE HUNDRED-YARD STARE.

Deidre Lee Pate, 1972.
Sent by mom Vicki.

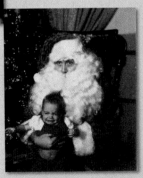

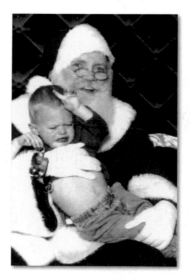

PUT. THE COOKIE. BACK.

Writes Tommy Carson's aunt, Jackie Miscevich, "My sister 'brilliantly' took a cookie out of his hand right before the picture was snapped" in 2005.

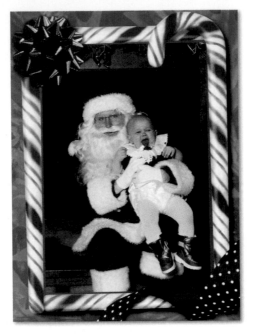

THESE BOOTS WERE MADE FOR WALKIN' . . . FAR AWAY FROM HERE.

Good thing Cassidy Paige Kruchten wore such a pretty holiday dress, 2002. Sent by grandpa Joel Kruchten.

SANTA MAY HAVE SPENT TOO MUCH TIME ON THE TANNING BED.

Jennifer Grahn sent this one of herself in 1967, before all those skin cancer studies.

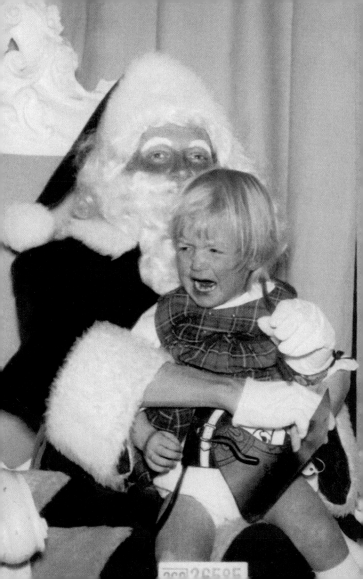

Chapter 4

WANT A SMILE?
IT'LL COST YA.

In desperation, adults will ply a weeping child with toys or candy in hopes of getting a few seconds of compliance for a photo. Our observations indicate that this accomplishes nothing except teaching kids that maybe later on, they can be paid for good grades.

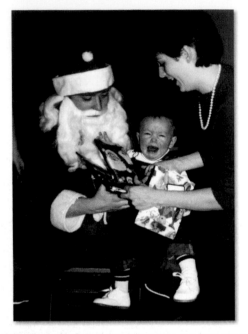

"EEEWWW, THESE ARE SHAPED LIKE <u>BOOKS</u>!"

In spite of the instant gift gratification, Brian Rix
always hated visiting Santa. 1986 photo sent
by parents Mike and Jane.

THAT'S IT, HOLD OUT FOR
THE STUFFED ANIMAL.

Eric Anerino (left) is not about to settle
for candy canes when twin brother Scott
gets plush, 1989. Sent by dad Greg.

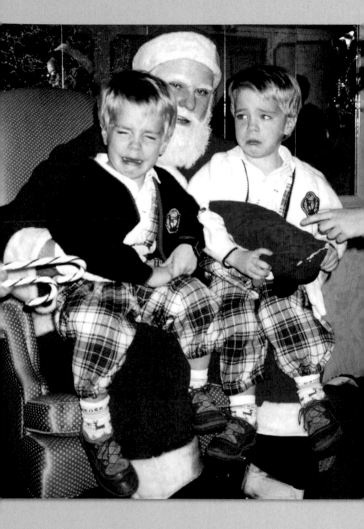

"MY SHIRT? I JUST WORE IT TO GET PAST SECURITY."

The "I ♥ Santa" shirt is not a self-fulfilling prophecy for 10-month-old Ryan Mitchell, 2005. Sent by parents Mark and Nicole.

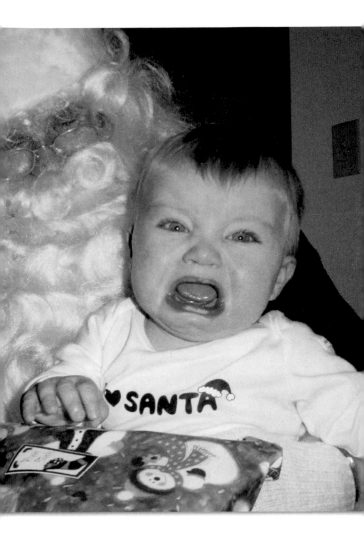

THIS GIRL CANNOT BE HAD FOR THE PRICE OF AN M&M.

Perhaps Courtney Bergsieker spots peanut butter cups off camera, 2000. Sent by parents Joe and Karyn.

"HMM, THIS BALL SHOULD JUST ABOUT FIT . . ."

Graham Henderson leads Santa into almost overwhelming temptation, 1991. Sent by mom Janet.

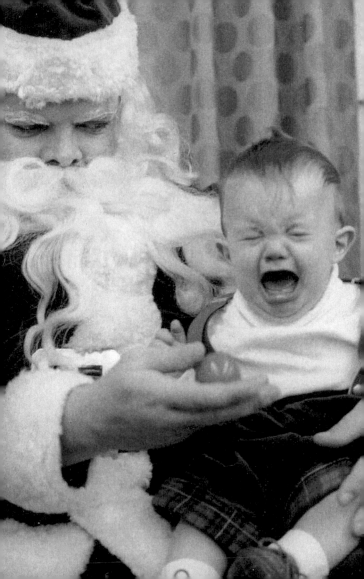

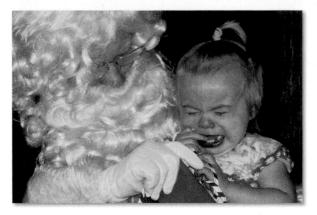

"NO WAY, I WANT IT IN CASH."

In spite of Santa's charity, Faith has lost hope, 2006.
Sent by mom Sarah Stockwell.

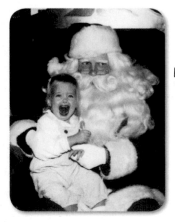

WILL SOMEONE PLEASE TAKE THE CANDY FROM THE BABY BEFORE THE SITUATION GETS STICKY?

Lauren Tazioli plus lollipop plus white beard equals trouble for Santa, 1987. Sent by parents Lou and Nancy.

"THE JINGLING IS SO HYPNOTIC. . . . I MIGHT . . . JUST . . . DOZE . . . OFF . . ."

Cole Ryan is not interested in joining Santa's sleigh team, 2006. Sent by mom Anne.

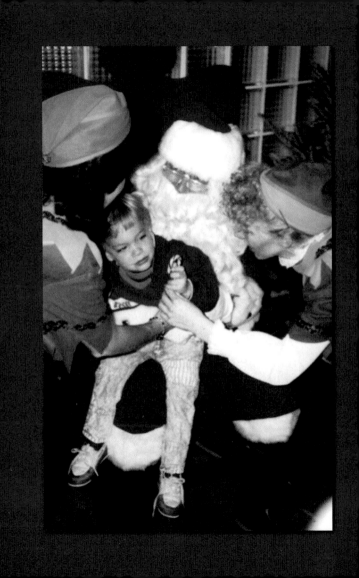

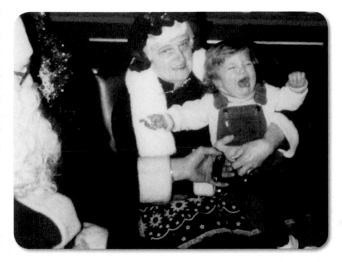

"THAT'S RIGHT, DEAR, KEEP CRYING TILL HE COMES UP WITH A DIAMOND."

Tracy Batdorf agrees that jingle bells are not a girl's best friend, 1980. Sent by mom Cathy.

WHERE'S THAT ELFIN MAGIC WHEN YOU REALLY NEED IT?

Christopher Wittenborn isn't accepting anything from those jolly green giants, 1989. Sent by mom Melissa.

Chapter 5
MISERY SQUARED

The crying spreads like a superbug, so virulent you can almost see it move from one child to another, and suddenly they're both hollering for dear life. And if you wait long enough, Santa will probably start too.

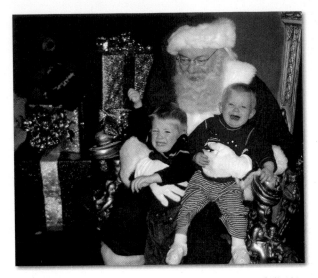

"BE GOOD, OR SANTA WILL WRAP YOU IN A BOX WITH ALL THE OTHER BAD LITTLE CHILDREN."

This Santa had good cry-dar, according to Sarah Carlson, mother of Andy and Anna, 2005. "As the kids approached he told one of his elves, 'Watch out, we've got some criers here,' even though they hadn't started crying yet."

"MY MOUTH IS BIGGER!"
"NO, MINE!"
"MINE!"

Katelyn (left) and Delia Bonnet, 2006.
Sent by mom Barbara.

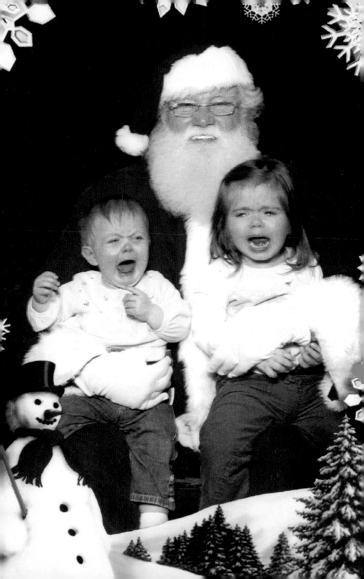

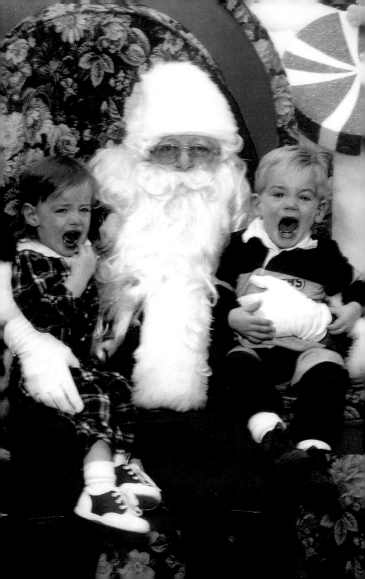

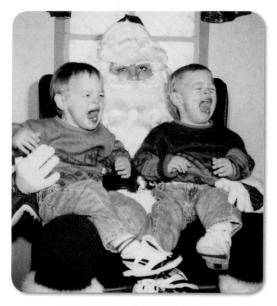

BEEN THERE, DONE THIS.

Twins Kurt and Kevin Byford, 1994. Writes
mom Mary Ellen: "As we were driving by a
mall, my sister thought it would be a great
idea [to visit Santa]. Did I mention that
my sister had no children?"

SANTA REALIZES HE LEFT HIS
EARPLUGS AT THE NORTH POLE.

Twins Abby and Trevor Casmere, 2002.
Sent by mom Beth, who notes, "We have
not been to see Santa since."

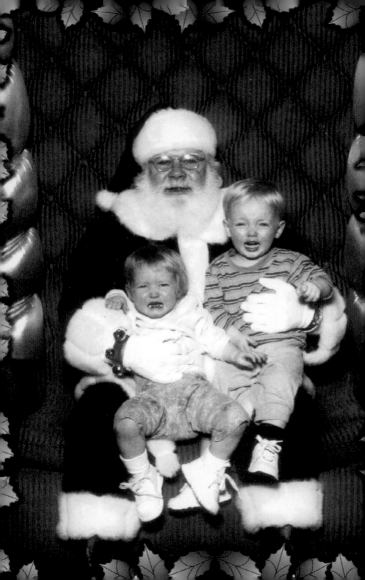

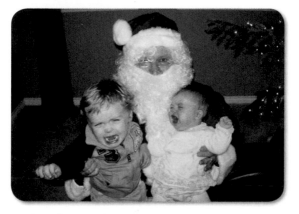

THE WINNER AND STILL CHAMPION BABY WRESTLER!

Cannon (left) and Anna Headley, 2006.
Sent by mom Julie.

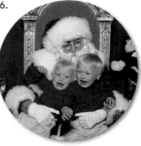

CRYING IS PROVEN TO BE CONTAGIOUS, ESPECIALLY AMONG TWINS.

Cade and Tyler Lussow, 2001.
Sent by mom Christine.

"WE DON'T SEE _YOU_ UP HERE."

Quinn Fitzgerald, with sister Cate, points a _j'accuse!_ finger at
the agents behind this treachery, 2001. Sent by mom Kristen,
who reports that she almost didn't buy the picture but
that it's now probably her favorite Santa photo.

"BUT WE DON'T WANNA MEDITATE WITH SANTA!"

Mike and Mary Margaret Sullivan, circa 1958. Reports Mary Margaret, "I've had a hinky feeling about bearded men since then."

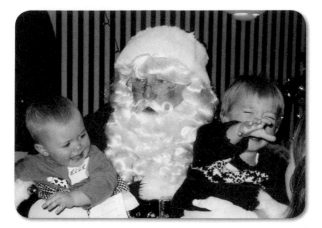

THE CLASSIC LUNGE PAIRED
WITH THE PITIFUL REACH.

Elle (left) and Bennett Munds try a two-pronged
approach to escape, 2003. Sent by mom Susan.

IT DAWNS ON SANTA
THAT HE HAS FOUR
MORE HOURS TO GO
ON HIS SHIFT.

Antigone Matsakis (left) and
Cindy Tagaris, 1991. Sent by
moms Joanne Matsakis
and Angela Tagaris.

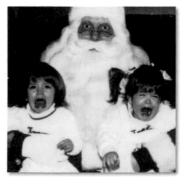

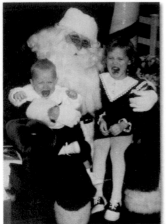

"LET'S JUST <u>SIT</u> HERE AND <u>SCREAM</u>."

Christopher (left) and Nicole Peters. Sent by mom Linda, who says she has been waiting since 1988, when this photo was taken, for the chance to make it public.

"TRY US AGAIN IN FOUR YEARS."

Adam (left) and Benjamin Rodenbostel stayed put just long enough for mom Margo to snap the picture. "They have not yet returned to Santa's lap," she reports. "They say maybe when they're 5."

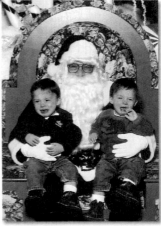

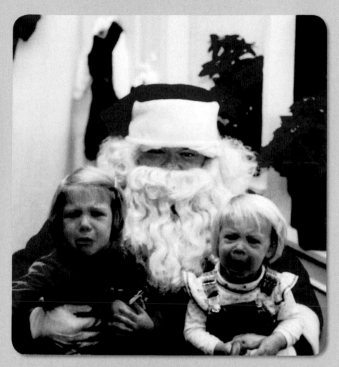

"DOES IT LOOK LIKE WE'RE HAVING FUN?"

Therese and Amy Sojka, circa 1990. Sent by dad Ron.

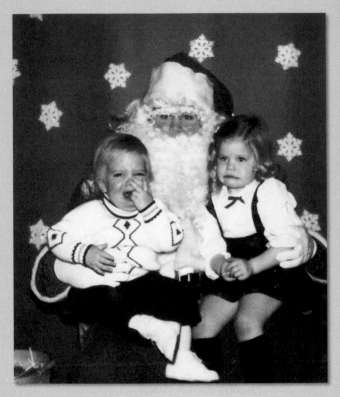

HONEST, HE'S <u>SCRATCHING</u> HIS NOSE.

Dave and Marti Sivesind, 1977. Sent by Dave.

TWO 1-YEAR-OLDS AT ONCE? SORRY,
THAT'S NOT IN SANTA'S CONTRACT.

Emma Walsh (left) and Grace Dynako, 2004.
Sent by mom/aunt Betsy Walsh.

"MISSION IN DANGER!
ABORT! ABORT!"

Cameron (left) and Abby
Tonkery, 2001. Sent by
parents Lisa and Gregg.

Chapter 6

IT'S ALL IN THE WRIST, AND THE HANDS, AND SOMETIMES THE KNEES

Besides skills in sleigh driving, toy manufacturing, and ho-ho-ho-ing, Santa also has to be good with his hands—specifically, maintaining a grip on a squirming, wailing child without appearing to be squeezing the life out of him.

"A PLAGUE ON BOTH YOUR HOUSES!"

Anna Creech, 2005.
Sent by mom Melissa.

**THE BEST SANTAS MAKE A DEATH GRIP
LOOK LIKE A LOVING HUG.**

Lily Beaurain, 2006. Sent by grandma Sue Beaurain.

"NO ELMO COULD BE WORTH THIS!"

Leah Filskov reconsiders whether the "visit Santa, get presents" arrangement is in her best interest, 2006. Sent by parents Wendy and Lou.

SANTA LIFTS AND SEPARATES.

Kay Coley sent this one of herself getting
unwanted support from St. Nick, with
brother David in 1951.

"WELL, AT THE NORTH POLE
THIS IS HOW WE BURP 'EM."

Julie Leek doesn't stand a chance
against those big white paws, 1978.
Sent by mom Linda Egner.

"THEY'RE TAKING ME TO THE STOCKADE!"

Santa can relax a bit, knowing that Jack Gambro
is securely fenced in, 1996. Sent by mom Beth.

"PARDON ME, SIR, I BELIEVE YOU DROPPED THIS."

Dennis Johnson remembers waiting for what seemed like hours for his son Michael to see Santa in 1980. After all that, "there was no way we were going home without a picture."

WELCOME TO THE MALL PRODUCTION OF "SWAN LAKE."

Santa and Drake Daccardo in a magnificent pas de deux, 2001. Sent by family friend Pat Kopsian.

"THROW ME A LIFE PRESERVER!"

This Santa—admittedly an amateur—has a tenuous
grip on Jane McNamara, 2006. Sent by dad Chris.

LET'S TWIST AGAIN.

Max Levenson, 2001. Writes mom Christine,
"He is Jewish, which might explain why
he's so scared of Santa."

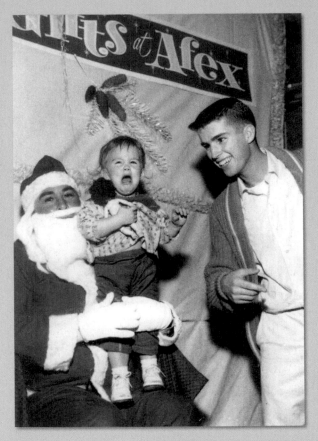

"KID, YOU'RE STANDING ON MY JINGLE BELLS."

Kim Weithman sent this photo of herself, Santa, and her dad in the early 1960s in Istanbul, proving that Kris Kringle's reign of terror knows no international boundaries.

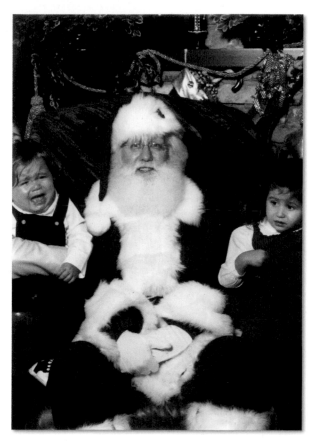

KEEP YOUR HANDS TO YOURSELVES, EVERYBODY.

Santa is quite happy to let the armrests hold Richard and
Mary Rita Moran, 2006. Sent by mom Karen Rugai Moran.

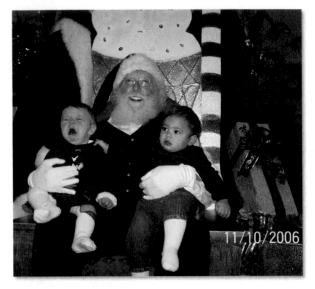

11/10/2006

"NO WORRIES, BUD. I'VE GOT YOUR BACK."

Bradley Zilinsky tries to comfort Breanne Schultz with
little success, 2006. Sent by Bradley's grandma
and Breanne's mom, Debra Schultz.

"WHO IS YOUR DECORATOR? FIRE HIM!"

Sean Lewis's basic black ensemble makes him
stand out against the mall's baroque holiday
decor, 2002. His screaming makes him stand
out, too. Sent by dad Steven.

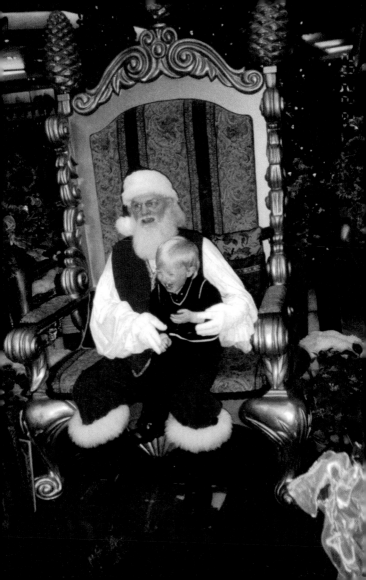

THE BIGGEST SANTA HANDS IN ALL THE LAND.

Michael Hall, 2005. Sent by grandparents Stephen and Margaret Tennis.

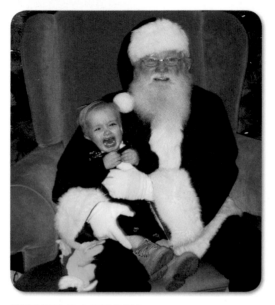

THIS HOLD COMBINES GENTLE CRADLING WITH A GRIP THAT SAYS, "YOU AIN'T GOING NOWHERE, SON."

Brendan Smith, 2004.
Sent by mom Linda.

"SHAKING THEM IS BAD? ARE YOU SURE?"

Mark Bliss, 2001. Sent by parents Mark and Michelle.

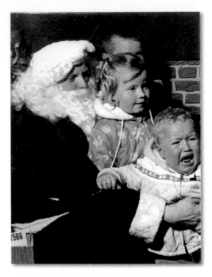

"JUST HOP ON MY HARLEY, KIDS. WE'RE GOIN' ON A JOYRIDE."

From right, Trish, Ann, and Jerry Loftus
(mostly hidden), 1964. Sent by Trish.

WHEN ALL ELSE FAILS: THE KNEE-LOCK.

Santa uses his secret weapon
on Lindsay Plikuhn, 1985.
Sent by dad Marty.

"THEY'VE GOT ME, BOYS. THE JIG'S UP."

Santa uses Jack Lynch as part of his restraint system on Elena (left) and Renee, 1991. Sent by mom Deb.

Chapter 7

SANTA CLAUS IS COMIN'. . . AFTER YOU

Some of these kids had every reason to fear Santa.

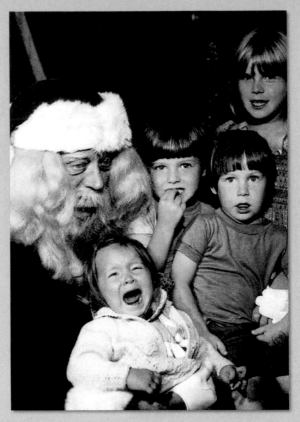

COULD SOMEBODY CHECK SANTA'S PULSE?

Note how the closer the children are to Santa, the more scared they are. In descending order of fear, Olivia, Aric, Andrew, and Amanda Arduini, 1979. Sent by mom Jan.

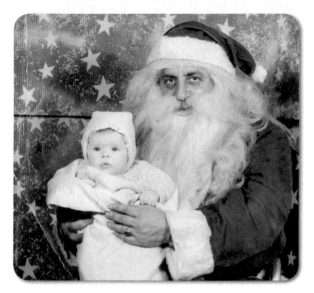

"CAN I BORROW HER FOR MY PROBATION HEARING?"

"I can't believe my mother let him hold me," says
Vicki Hebein of this 1953 encounter.

"IT'S OK. . . .
KIDS LOVE ME!"

"I don't think we ever did
coerce him to go see
Santa after that first time,"
says Kris Fox of son Alan
in this 1981 photo. We
can't imagine why.

HIS CHEEKS WERE LIKE ROSES, HIS SKIN LIKE PAPIER-MÂCHÉ . . .

Mark and Laura Diatte, 1967.
Sent by Laura Diatte Wilkens.

"PSSST! GET AWAY, HE'S THE REAL KILLER!"

An unidentified bystander
tries to save Lynn and
Kaye Sandeman, 1953.
Sent by Kaye.

"AT LAST, I HAVE EVERYTHING I NEED FOR MY NEW EXPERIMENT. BWAH-HAHAHA!"

Off to the laboratory with Brianna and
Brendan Miller, 2003. Sent by mom Mary Pat.

"THE BLACK EYE? GOT IT IN A FIGHT WITH A 10-YEAR-OLD."

Graham (left), Tyler, and Madeline Nelson, 2006, with a Santa you wouldn't want to owe money to. Sent by mom—the kids' mom, not Santa's—Joanna.

"ALL I NEED ARE SOME RAILROAD TRACKS AND SOME ROPE, AND I'M GOOD TO GO."

Samantha Wilk, 2005, with a Santa who's some kind of cross between Snidely Whiplash and W. C. Fields. Sent by mom Stephanie Wilk Peterson.

Chapter 8
WRITHE SPIRITS

We like these kids. They're not going to take this Santa business lying down, or even sitting and crying. They're going to take it squirming and twisting and wriggling until they've broken free from his clutches.

IF THE BOY AIN'T HAPPY,
AIN'T NOBODY HAPPY.

Dan Decker, 1973. Sent by mom Bonnie,
who reports that Dan never did warm to
the old man, though he accepted the
presents willingly enough.

"I CALL IT THE SANTA SLIDE."

Charles Desnoyers starts a new dance craze in 2005. Sent by mom Kristin.

A FEW . . . MORE . . . INCHES. . . .

Mike Devlin squirms his way out of the frame, circa 1952. Sent by sister Marie Epley.

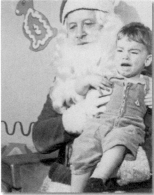

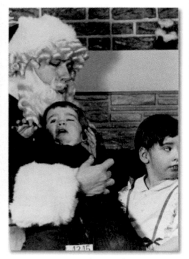

IS THE CAVALRY COMING?

Frankly, Santa's Shirley Temple curls *are* a bit unnerving. Marie Epley sent this one of herself (right) and sister Sue Devlin, circa 1963.

SORRY, BUT SANTA LANE IS A DEAD END.

Annelise Dusterberg deeply regrets taking that wrong turn, 2005. Sent by mom Stacie.

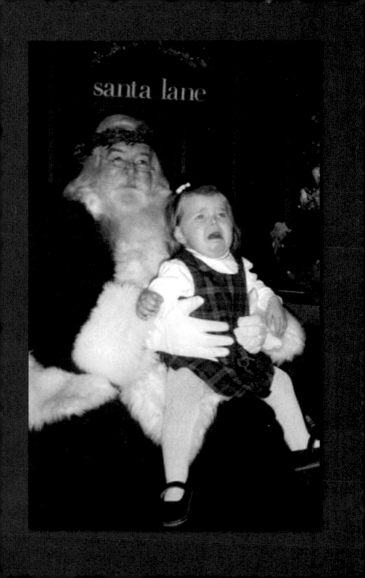

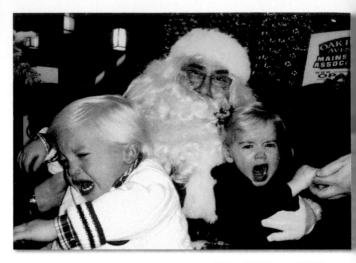

"RUN! WE'LL MEET IN SWITZERLAND AFTER THE WAR!"

Ryan and Kylie Kolacki practiced all week, reports mom Mary, but they still weren't ready for prime time, 2006.

"WHAT? SHE WAS THIS WAY WHEN I GOT HER."

Andrea Foulk, 2005. Sent by mom Kelley.

NOWHERE TO RUN, NOWHERE TO HIDE.

Jordan and Taylor Hanson try to make a dash for it,
but older brother Justin knows it's hopeless, 1988.
Sent by dad Bill.

45545

"HEY, KID, DON'T FORGET WHO THE STAR OF THIS SHOW IS."

Bryan Kozoman upstages Santa in 1990.
Sent by mom Linda.

NOTE TO SANTA: "GARDEN" DÉCOR IS NOT SOOTHING TO THE CHILDREN.

Bryan's sister, Janet Kozoman, who probably
harbors a fear of trellises to this day.
1984 photo sent by mom Linda.

TWIST AND SHOUT.

After ten attempts at getting a picture of Jon Henry,
Juanita Michalski finally told the photographer
to just shoot it in 2000. "She said 'Merry
Christmas' and gave it to me free."

LITTLE-KNOWN FACT: GROUCHO MARX ONCE PLAYED SANTA CLAUS.

You bet your life Ella Min Dunavan is scared, 2003. Sent by mom Elana Min.

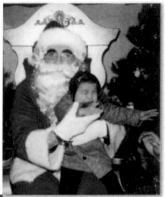

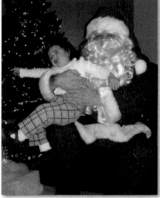

DID SANTA REMEMBER HIS ATHLETIC SUPPORTER TODAY?

Good thing Olivia Perez took that self-defense class, 2005. Sent by parents Ginger and Steve.

LEARNING TO RUN . . .
FOR HIS LIFE.

Christopher Sigel "was just getting comfortable with walking," writes dad Thomas. Here Christopher opts for the accelerated program, 1995.

DON'T WORRY, YOU'LL HAVE WORSE DAYS THAN THIS.

Robilyn Rodica on "the worst day of my two years of life," circa 1980.

AN OFFER THEY COULDN'T REFUSE. (UM, ARE THOSE BULLET HOLES BACK THERE?)

Jill Barnes, Holly Barnes, Stephen Retherford, Martina Retherford, and Robert Retherford (trying to hold Martina), 1975. Sent by Hazel Retherford, mom of Stephen, Martina, and Robert.

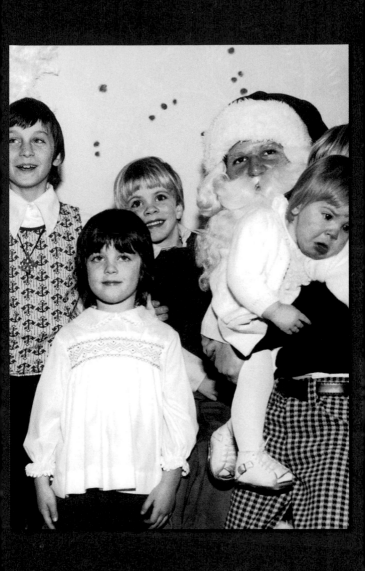

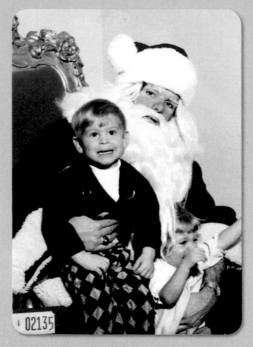

02135

"MY BROTHER'S PANTS WILL DISTRACT THEM WHILE I FLEE."

They distracted us, too; we didn't even see
John Dunkin's sister Denise at first in this
1972 photo. Sent by John.

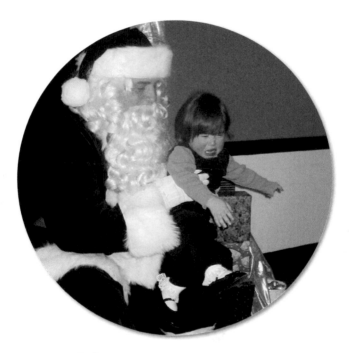

"I CAN'T GET NO . . . SOLID TRACTION."

Genevieve Talamantez at an office party in 2006.
Yeah, Genevieve, that's how we feel about
'em too. Sent by mom Deborah.

Chapter 9
DON WE NOW . . .

It's no surprise to see children all decked out in their holiday finery for their photo opportunity with Santa. But St. Nick himself has been making more fashion statements in recent years. Apparently the scarlet suit with white fur trim, matching hat, and big black boots wasn't distinctive enough.

"DOESN'T HE KNOW THIS AFFAIR IS BLACK TIE?"

Santa is quite underdressed next to a tearful-but-chic Olivia Burgess, 2001. Sent by mom Elizabeth.

"MOM, ARE THOSE SLEEVES GONNA EAT ME?"

Santa's voluminous sleeves yawn before Katie Kudrna, 1998. Sent by mom Georgine.

HOW SANTA DRESSES ON CASUAL FRIDAYS.

Tyler Nelson's plaid jacket sets a rugged fashion example that Santa would do well to follow, 2001. Sent by mom Joanna.

WHEN PRINTS COLLIDE.

Lindsey Wehking (right) clashes with Santa in more ways than one, 1997. At least she matches sister Madeline. Sent by mom Shirley.

A WEE BABY, A NOT-QUITE-WEE-ENOUGH HAT.

At 2 months, Hannah Vuillaume could be crying about anything, 2006. Sent by parents Nicole and Desi.

126

"I'M A LUMBERJACK AND I'M OK . . ."

Go ahead and laugh, but at least Eli Roos got in this 2006
picture. Mom Peggy reports that his sister wouldn't
go near that bug-eyed elf.

"TELL PETA IT'S **FAKE** LEOPARD FUR!"

Gracie Tuohy gets on the bad side of the animal
rights movement, 2006. Sent by mom Susan.

"DO THESE HORIZONTAL STRIPES
MAKE ME LOOK FAT?"

Gracie (left) and Lily Rubeck are small;
they can get away with it. 2005 photo
sent by grandma Rita Stevenson.

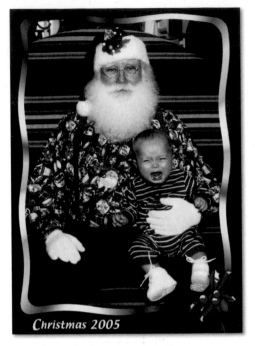

Christmas 2005

SUSPENDERS <u>AND</u> A BELT?
CALL THE FASHION POLICE!

Jack Allen, 2005. Sent by mom Karin.

BARE WRISTS BEFORE FIVE O'CLOCK!
WHAT WILL THE VANDERBILTS SAY?

Brendan Zurek, 2005. Sent by grandparents
Tom and Sue Zurek.

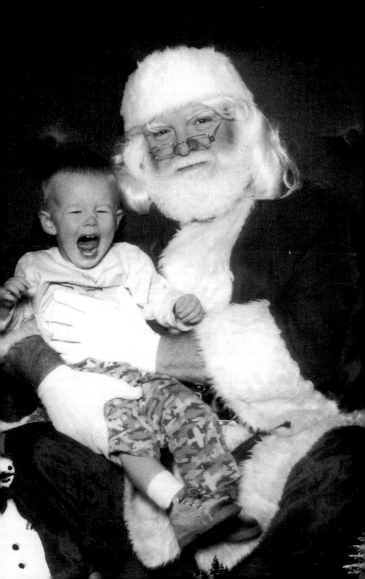

Chapter 10
CRYING IS ONLY THE BEGINNING

Visiting Santa can provoke reactions besides tears. Are the kids bored? Startled? Worried? Wondering where their next handful of Cheerios is coming from? Or just too terrified to cry?

THEY'RE CRYING ON THE INSIDE.

Cousins Malcolm Jennings (left) and Matthew Biancheri, 2005. "Both were really scared but tried valiantly to hold it together for the picture," writes Matthew's mom, Amy.

"ALL IS LOST. WE MUST TAKE THIS DEFEAT LIKE GENTLEMEN."

Ben and Jerry Dykstra stoically accept their fate, 1950s. Sent by Jerry.

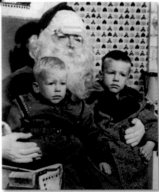

YES, SIR, YES, SIR, THREE BAGS FULL.

Don't think for a minute that all three triplets—Nick, Isabella, and Emilio Flores—got through this whole incident without crying. Nick started up right after this 2006 photo was taken. Sent by dad Rey.

"UH-OH . . . HE HEARD ABOUT THE JELL-O AND THE TOILET BOWL."

Morgan (left) and Kaitlyn Clark have been found
out, 2003. Sent by parents Tina and Chris.

"I'LL BE GOOD ALL YEAR. JUST RESCUE ME."

Allison Hahn is the lucky one; she's unconscious.
Not so fortunate are cousins Tess Walsh (screaming)
and a very tentative Emma Walsh, 2005.
Sent by aunt/mom Betsy Walsh.

"THIS IS QUITE CLOSE ENOUGH, THANK YOU."

Dad's proximity and brother Jackson's smile are
not persuading Annie Edwards to get on Santa's
lap, 2005. Sent by parents Cara and John.

"I LIKE TO STUFF THE BEARD UP MY
NOSE AND THEN SNEEZE ON THE KIDS."

Fun with facial hair at the expense of Pat Joe
Hassett, 2004. Sent by parents Gina and Patrick.

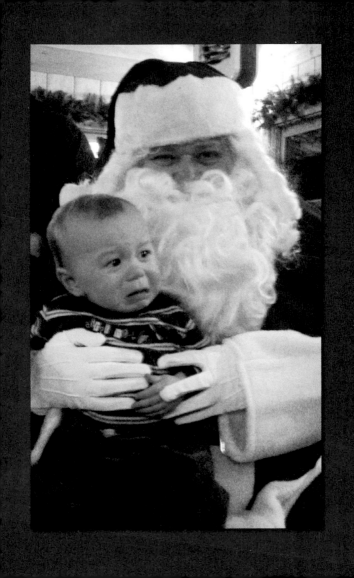

WINNER OF THE MVP AWARD:
MOST VEHEMENT POUTER.

Max Lenski does not want to be a good sport about
this, 2006. Sent by mom Becky and grandma Sue Beaurain.

"I TOLD YOU, I DON'T KNOW WHERE
THE COOKIES ARE!"

Dawn Howard under interrogation in 1966.

"I'M GETTING TOO BIG FOR THIS GROUP.
I'M STARTING A SOLO CAREER."

The Roth family singers: Shane (left), Chase,
and Nathan, 2006. Sent by dad David.

"OOOOO, VISIONS OF SUGARPLUMS DANCING IN MY . . . AAAUGH!"

Kylie Sullivan gets the surprise of her young life, with sibs Brendan, Lia, and Shayla, 2006. Sent by parents Bill and Michelle.

"OK, SANTA, IF YOU'RE GOING TO BRING ME THINGS, HOW ABOUT STARTING WITH SOME SHOES."

Alayna Olson, 2005. Sent by parents Kate and Eric.

"KID, IF YOU'RE GONNA THROW UP, DO IT OVER THERE."

McKenzie Pryor, 1997. Sent by mom Tawna.

"THINK . . . THINK . . . WHAT <u>DO</u> I WANT FOR CHRISTMAS?"

Areanna Ortiz, 2006. Sent by mom Elena Manzo.

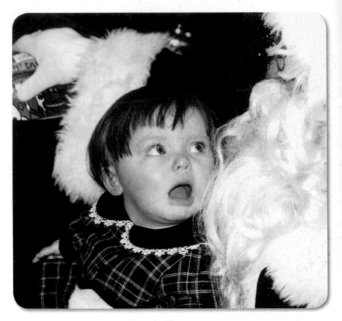

OF ALL PEOPLE! SANTA WITH HIS HAND IN THE COMPANY TILL.

Julia Mostardo catches St. Nick red—er, *white*-handed, 1996. Sent by mom Susan.

"I JUST KNOW BALTO WILL SAVE US."

Balto (upper right) comes to the rescue of Kelsie (left) and Delaney Roberton, 1999. Sent by parents Peter and Donna.

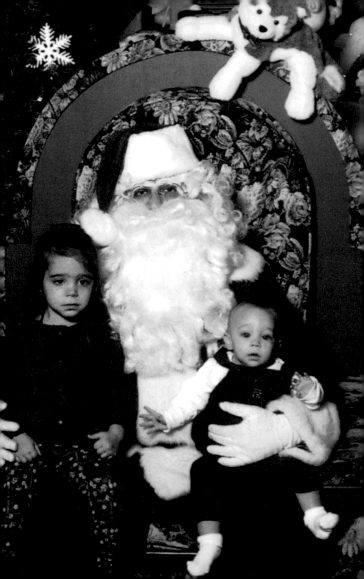

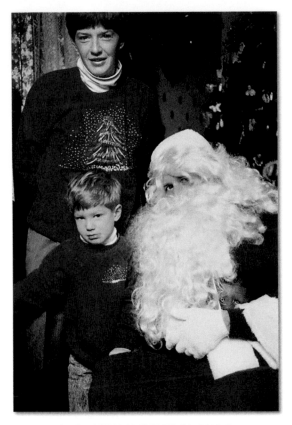

**"CAN WE MOVE THIS ALONG?
I'M LATE FOR MY FOUR O'CLOCK."**

Mason Rose clearly has other things
to do, 1991. Sent by mom Priscilla.

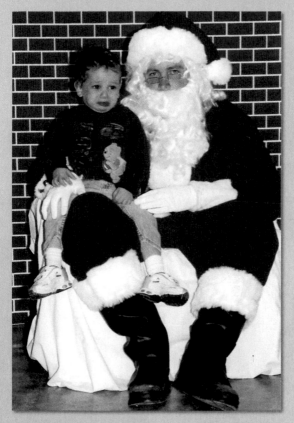

GEE, SANTA ALWAYS SPEAKS HIGHLY OF <u>YOU</u> . . .

"That was a mean and smelly Santa," Ben Rupnow said
after their 2005 meeting. Sent by mom Alina.

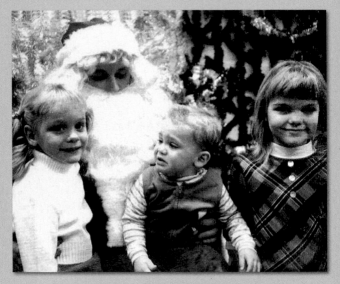

IF YOU CAN'T COUNT ON YOUR OWN SIBLINGS, WHO CAN YOU COUNT ON?

James Sapyta (center) gets no help from Chris and Cathy, 1971. Sent by mom Maria.

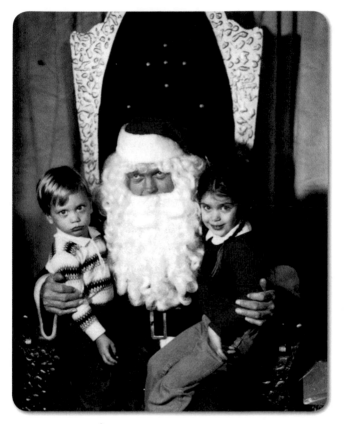

ARE WE SURE SANTA HAS HAD HIS SHOTS?
Bret and Arika Blankenship, circa 1978.
Sent by mom Paula Smartt.

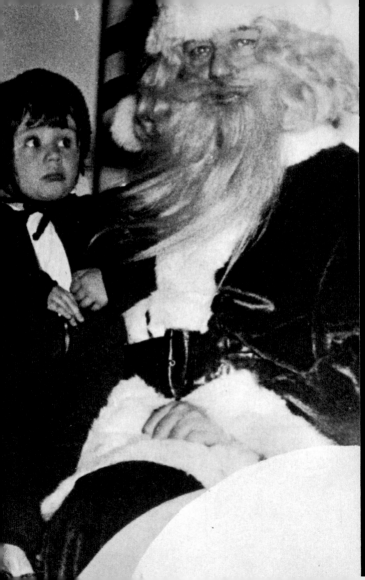

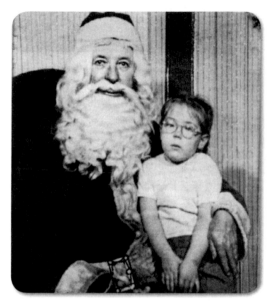

YOU ARE GETTING VER-RY SLE-E-EPY. . . .

Cindy Rhoades, circa 1954. Sent by husband Jim Siergey.

SANTA'S BEARD ALSO ACTS AS A DIVINING ROD, POINTING TOWARD ANXIOUS CHILDREN.

Jeanie Kedzior, 1940s. Sent by big sister Diana Strzelinski.

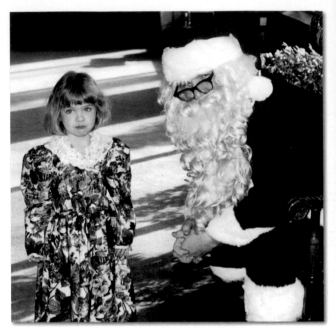

"YOU SAID NOT TO TALK TO STRANGERS. AND THIS DUDE IS DEFINITELY STRANGE."

Melanie Wittenborn learned a thing or two in "Stranger Danger" class, 1995. Sent by mom Melissa.

"DEAR LORD, JUST DON'T LET HIM SIT ON ME!"

During the two-hour wait in 2001, Tommy Shaw was happy and excited about seeing Santa. Then he saw Santa. Sent by parents Brian and Viki.

"THIS IS NOT WHAT I HAD IN MIND FOR A FIRST DATE."

Melissa Wittenborn reports that she was PO'd that her mother wanted her to sit on Santa's lap with her boss's son in 1963. "I consoled myself with candy and shopping."

"CAN I HAVE MY DPT SHOT INSTEAD?"

Lauren Reid (center) would rather be doing absolutely
anything else, unlike happy sibs Megan and Evan, 2006.
Sent by mom Jane.

"SERIOUSLY, HOW DO YOU
GET IT SO CURLY?"

James and Mary Clare Walsh,
2006. Sent by dad Tim.

"AND I THOUGHT GETTING
FIXED WAS EMBARRASSING."

Peyton Callaghan was a very cooperative subject
for this 2004 pose. "He stopped barking for
two seconds for the photographer to take the
picture," writes owner Maggie Callaghan.

"WHEN HE COMES DOWN THE
CHIMNEY . . . WE'LL BE WAITING."

Jake and Rocky plot their revenge for this
humiliation, 2006. Sent by Cindy Crawford
of Palos Hills, Illinois.

Chapter 11

STRONG-ARM
TACTICS

*"Ah, but a man's reach should
exceed his grasp—or what's a
heaven for?" Poet Robert Browning
must have had a "Scared of Santa"
experience somewhat like these.*

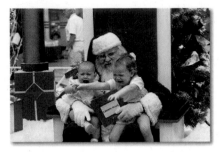

THE ONLY THING BETTER THAN A
CHRISTMAS COOKIE? YOUR SISTER'S ARM.

Jenny Rote (left) prepares to sample sister Nicole, who
is somewhat distracted, 2000. Sent by mom Jody.

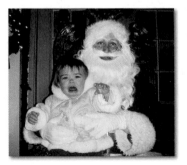

"YOU! YOU DID THIS TO ME!"

Mackenzie Cote can't believe her parents'
betrayal, 2006. Sent by mom Chris.

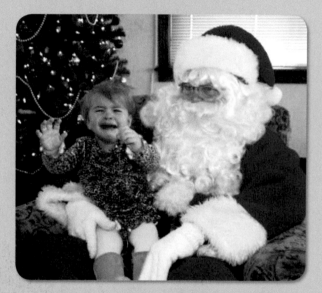

CLAWS VS. CLAUS

Ava Bruns, 2006. Sent by mom Nancy.

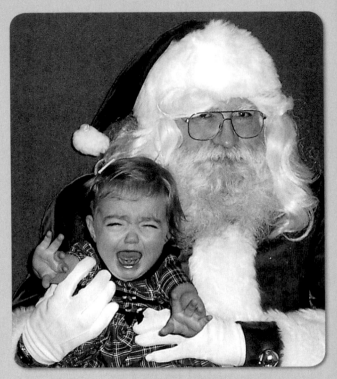

"STOP! DON'T COME ANY CLOSER!
SAVE YOURSELF!"

Thirteen-month-old Marisa Grigolo learns
why thirteen is an unlucky number, 2006.
Sent by mom Cheryl.

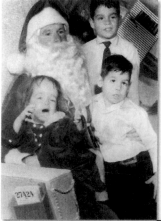

"MAMMY! MAMMY! I'M COMIN'!"

Barbara Devlin does her best Al Jolson, but brothers Mike and Dennis are unimpressed, circa 1956. Sent by sister Marie Epley.

WE'LL HAVE WHAT SANTA'S HAVING.

Price Kovach, 2005. Sent by mom Kristen.

"HELP! HE THINKS I'M A CANDY CANE!"

Maya VanderKamp laments her unfortunate
wardrobe choice, 2006. Sent by dad Nathan.

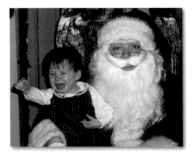

WIPE THAT SMILE OFF YOUR FACE, MISTER.

Mickey McGrory futilely
hailing a cab in 2006. Sent
by parents Beth and Mike.

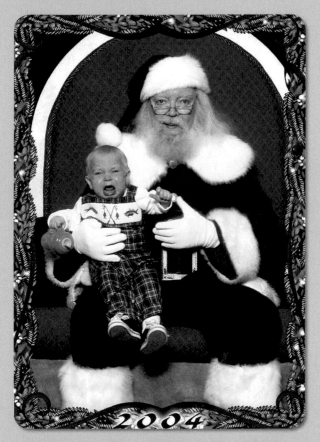

"I JUST HOOKED A LARGE-MOUTH INFANT."

Price Kovach thinks something is very fishy
here, 2004. Sent by mom Kristen.

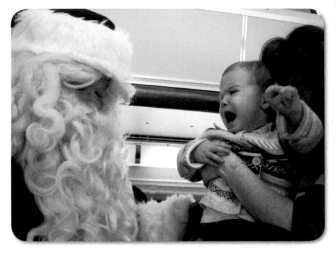

"LOOK AT ME WHEN I'M SCREAMING AT YOU!"

Hard to blame Santa for not making eye contact with
Savannah Somolik, 2006. Sent by mom Seana.

"HEAL, BROTHERS AND SISTERS! HEAL!"

Gina (left) and Lori Arnieri, 1980. Says mom Shirley:
"Gina put on a fake smile a few times and then
resigned herself to all the screaming. I finally told
the photographer, 'Just take it already.'"

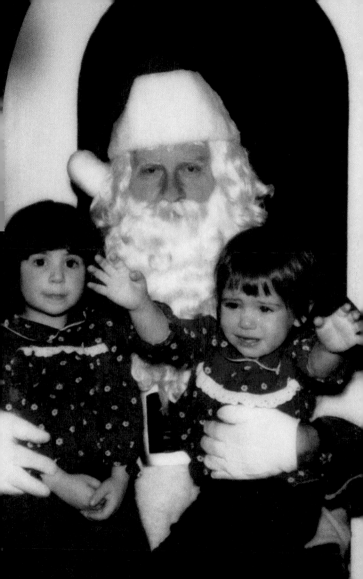

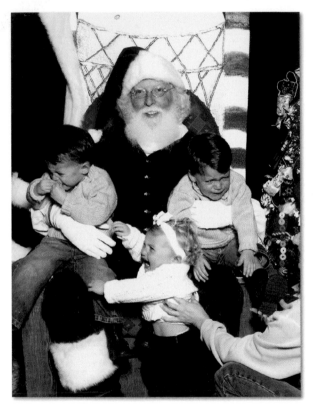

BEST AD FOR PROZAC WE'VE EVER SEEN.

Kyle, Jacob, and Natalie Hrkl with a remarkably mellow
Santa, 2006. Sent by mom Kathy Kaufman-Hrkl.

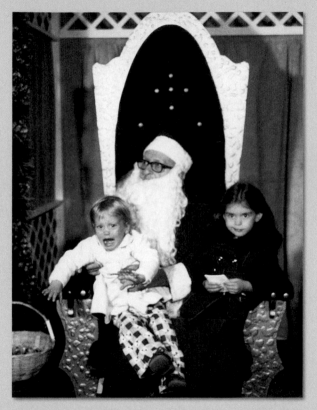

"DO YOU RECYCLE THESE OR JUST TOSS 'EM?"

Santa looks ready to jettison Bret Blankenship as
world-weary sister Arika waits with her list, 1977.
Sent by mom Paula Smartt.

Chapter 12
THE MOM STAYS IN THE PICTURE

Our research shows that the inclusion of a parent or guardian does nothing to stop the crying, but it does help get the %&^$! picture taken already.

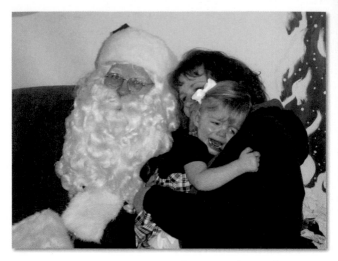

"BUT . . . WHEN WILL I EVER SEE YOU AGAIN?"

Beth Carlson clutches mom Missy, who appears only because there was no other way to get this 2004 picture of Beth. "Mercifully," Missy says, "Santa still brought her a play kitchen."

DON'T WORRY, SONNY, THAT'S JUST SANTA'S BODYGUARD.

Actually that's James Dixon with grandson Riley in 1996.

AT THIS DECIBEL LEVEL, IF YOU GET ANY CLOSER YOU RISK PERMANENT HEARING DAMAGE.

Barbara Bizzarri with granddaughter Ashley Black
and Santa staying safely out of the way, 1999.

HONEY, I SHRUNK THE KID, MOM, AND SANTA TO THE SIZE OF A CHRISTMAS TREE ORNAMENT.

2004 photo sent by Jodi Gassmann, who says daughter
Gracie "insisted I come with to sit on her lap for
the photo. A lot of good that did!"

"SANTA ALWAYS LIKED YOU BEST!"

Michael Fehser (Santa's favorite), mom Ann, and screamer Tyler, 1993. Sent by dad Keith.

"GEEZ, MOM, HOW MANY BODIES IS HE HIDING IN THAT SUIT?"

Claire O'Dea and son Aidan, 2006.

THROW SANTA FROM THE TRAIN.
Brendan Smith with dad Richard
on the "Santa Train," 2005.

"IF YOU THINK HE'S SO
GREAT, YOU SIT ON HIM!"
Haley Rogge scrambled to mom
Shelley the moment she realized
whose lap she was in, 2006.

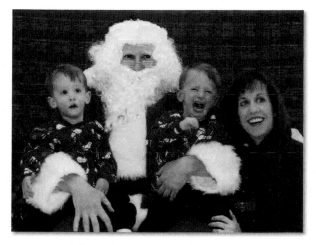

"ACTUALLY, THEY'RE PRETTY EASY TO TELL APART."

Twins Joey (left) and Tommy Sullivan
with mom Nancy, 2002.

"THAT'S FUNNY, SINCE I STARTED PINCHING HER, SHE CRIES HARDER."

Cathy Speer inserts Kelly into the scene
while Kevin and Santa wait with varying
levels of patience, 1993.

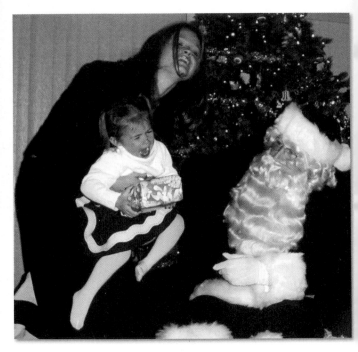

PHYSICS QUIZ: ARE KIDS HEAVIER WHEN THEY'RE SCARED?

Jody Saso heaves daughter Alyssa to Santa at a family
Christmas party in 2003. Sent by grandma Bobbi Pote.

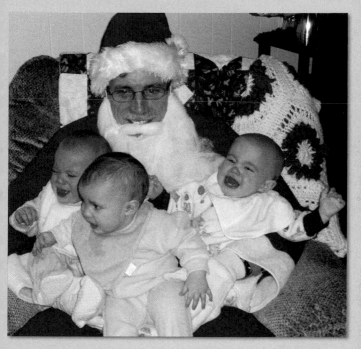

HIS BEARD IS MELTING, MELTING!

Triplets Thomas, Peyton, and Colin Olinski relish their
first Christmas, 2006. Sent by mom Jennifer.

"SIR, THE IDEA IS TO HAVE HER SIT IN _MY_ LAP."

Tim and Julia
Abbott, 1998.

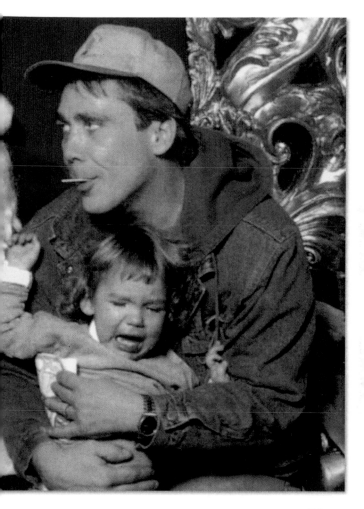

185

HE AIN'T HEAVY, AND HE AIN'T MY BROTHER

Ever since Cain and Abel, siblings have been at odds with each other. And if one sibling has a few years on another, good luck getting them on the same page when it's time to call on Santa. As the littlest tots go berserk, the older ones focus on staying on the big guy's good side.

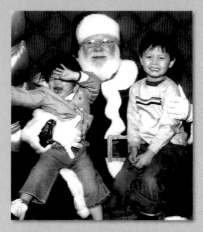

THE WHIRLING DERVISH GENE CAN STRIKE
ONE OUT OF EVERY TWO SIBLINGS.

Katie Ellman goes into a tailspin on Santa's knee
while brother Matthew keeps his cool, 2004.
Sent by mom Jocelyn.

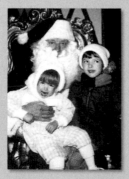

"UH, MY PARENTS FOUND
HER ON OUR DOORSTEP.
YEAH, THAT'S IT."

Kellie (left) and a nonchalant Scott
Case, 1976. Sent by mom Shere.

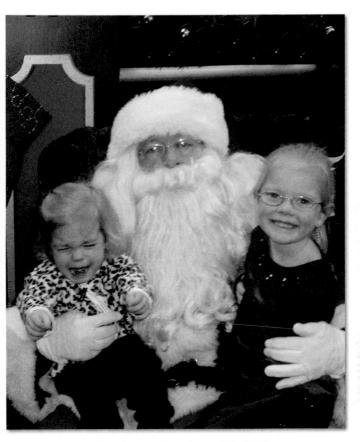

THE PERFECT STOCKING STUFFER—
JUST STUFF 'ER IN THE STOCKING.

Emma (left) and Hannah Beste, 2005.
Sent by mom Suzanne.

THAT'S RIGHT, CLOCK HIM ON THE NOSE. SEE HOW MANY MY LITTLE PONYS _YOU_ GET.

As Sean proceeds to ruin everyone's gift prospects, Kelly (left) and Casey put up a brave front, 2002. Sent by dad Jeffrey Boland.

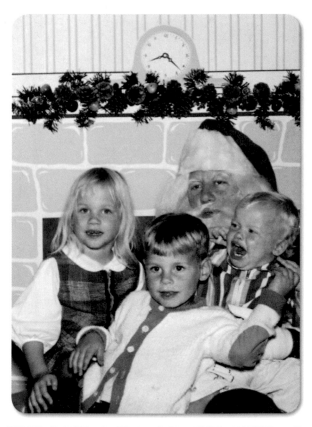

"THE VOLUME CONTROL IS RIGHT BACK HERE . . ."

Pat Faherty sent this photo, circa 1967, of herself (left) and
siblings Jim and Michele. "I remember thinking at the time,
'Why is my sister screaming?'" Ah, Pat, you might as well
ask why the sun rises or why the river flows.

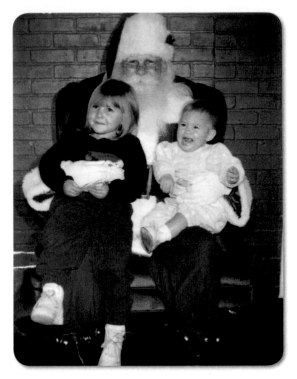

"DIDJA HEAR THE ONE ABOUT THE ELF AND THE REINDEER? . . . HELLO? . . . IS THIS MIKE ON?"

"They had the best Santa!" writes Laura Frumet of the mall where this 1990 photo of daughters Erin (left) and Jenna was taken. Jenna begs to differ.

IF YOU SMILE NICELY, YOU GET MORE PRESENTS.

Morgan Clark (right) determinedly tries to distinguish herself from identically dressed Kaitlyn, 2005. Sent by parents Chris and Tina Clark.

"HEY, WHADDAYA KNOW—IT'S FUN TO WATCH HER SUFFER!"

Connor Zautcke discovers the entertainment value of having a little sister, with Ava, 2005. Sent by mom Noreen Heron Zautcke.

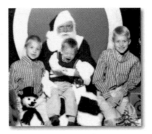

HE'S A REBEL, ALL RIGHT. FIRST HE REFUSES TO WEAR STRIPES, AND NOW THIS.

Andrew (left) and Michael Wright play it safe while Luke (center) tries to break free from convention, 2006. Sent by grandma Claudia Venie.

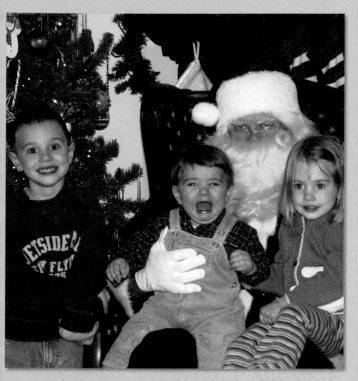

**SURE, HE'S SMILING—HE'S AT THE
PERFECT AGE: YOUNG ENOUGH FOR PRESENTS,
OLD ENOUGH TO STAY OUT OF SANTA'S LAP.**

Jakin, Jaxen, and Joryn Derry, 2004. Sent by mom Alicia.

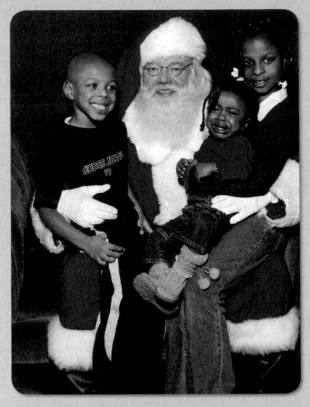

TWO OUT OF THREE KIDS SURVEYED RECOMMEND A VISIT TO SANTA. NEVER MIND THE THIRD.

Even the buffer of big sister Brianna's lap isn't enough for Mariah Hunter, 2006. Brother Christopher seems pleased to be out of the fray. Sent by mom Sheila.

"OUR OUTFITS CLASH, AND SO DO WE."

On second thought, the green gingham *does* tie it all together. April (left) and Laura Kornberger, 1977. Sent by mom Donna.

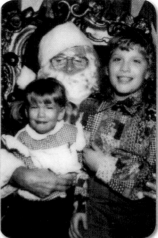

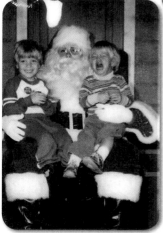

ONE OF THEM KNOWS WHERE HIS CHRISTMAS COOKIE IS ICED.

That would be Eric Kulze (left), with brother Patrick in 1985. Sent by mom Peggy.

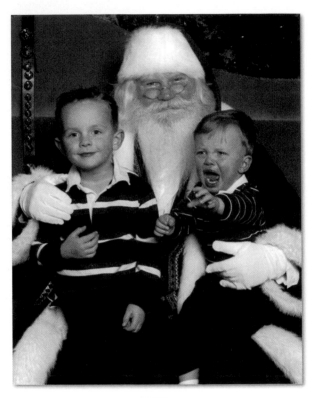

"WHY, YES, AS A MATTER OF FACT I _AM_ MOM'S FAVORITE." **"ARE NOT!!"**

Keegan (left) and Aidan Stocker set the stage for a lifetime of fraternal one-upmanship, 2006. Sent by parents Traci Lunsford and Ed Stocker.

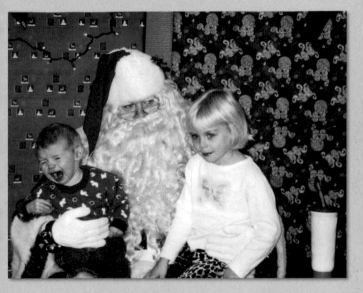

"PASS ME MY LONG ISLAND
ICED TEA, WILL YA, KID?"

Jamie (left) and Ellie Asa, 2001.
Sent by mom Mavis.

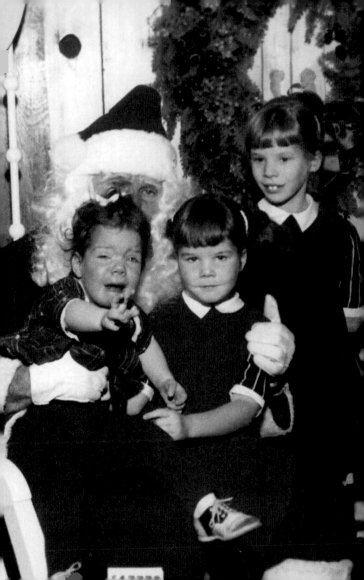

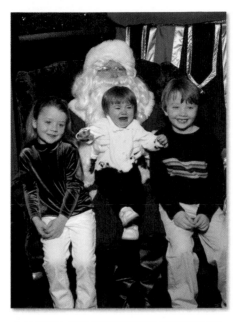

LOOKS LIKE SOMEONE DIDN'T GET THE "SMILE AND LOOK HAPPY" MEMO.

Megan, Lauren, and Evan Reid, 2005.
Sent by mom Jane.

"THIS IS <u>EXACTLY</u> HOW SHE TOOK MY BOYFRIEND AWAY FROM ME."

Valerie Klein (center) barely tolerates Pamela's
outburst as Vicki waits serenely for it to
end, 1967. Sent by Pamela Klein Meek.

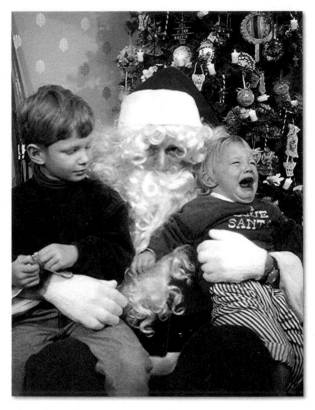

"LISTEN, CLAUS—LET'S WORK TOGETHER. YOU NEED LABORERS; I HAVE A SPARE SISTER."

Mason Rose looks ready to make a deal for Meredith, 1992.
And Santa looks receptive. Sent by mom Priscilla.

SANTA REGRETS HIS DECISION NOT TO GO INTO THE CAT-HERDING BUSINESS.

"Morgan [front] is usually the one inflicting terror on the twins [Grant and Kiwi], so it was a real treat for her to have Santa do the work for a change," write parents Mark and Mary Rose about this 2006 photo.

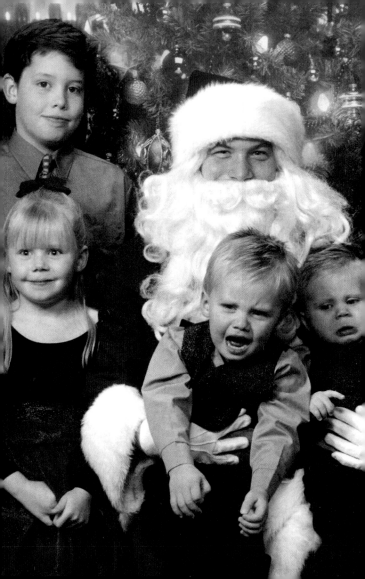

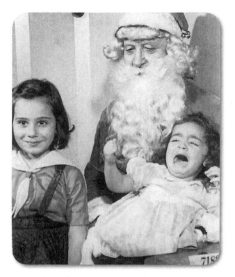

"I CAN'T <u>WAIT</u> TO SHOW THIS PICTURE TO HER FIRST BOYFRIEND!"

Louise Saccomanno looks a little too satisfied with sister Joanne's meltdown, 1955. Sent by Joanne.

"IT'S TOO LATE FOR THE OLDER ONES, THEY'VE BEEN BRAINWASHED. BUT WE STILL HAVE A CHANCE."

Zack and Ariel know the drill, but Jacob and Nathan refuse to comply, 2003. Sent by mom Kim Sanders.

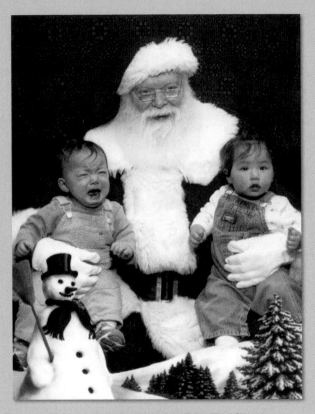

THE ONE IN PINK IS NOT IN THE PINK.

Marie (left) and Erika Scala, 2006. Sent by mom Emi.

"I LOST A TOOTH RIGHT HE—WHAT DO YOU MEAN, THIS ISN'T THE TOOTH FAIRY?"

Anna Waishwell and brother Dylan, who doesn't care
if it's the Easter Bunny—he wants out. 2004 photo sent
by grandparents Kathy and Greg Stockmal.

"THE REASON HE'S SO HAPPY IS THAT HE'S GOING TO EAT YOU!"

Kevin and Mia Taeyaerts, 2003. Sent by mom Eileen.

"NOW THAT I'M THREE, I'M SO OVER THIS."

Payton Tarulis-Morris tries to set an example for brother Owen, 2006. Sent by mom Rebecca Tarulis.

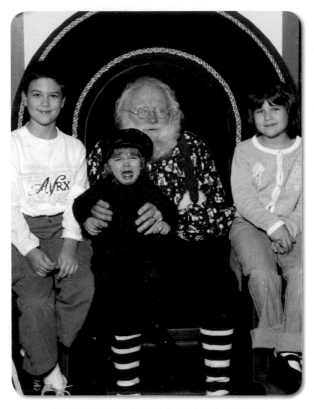

**"YEAH, SHE'S BEEN A DRAMA QUEEN
AS LONG AS WE'VE KNOWN HER."**

Anthony and Ashlen Trapalis indulge Brielle's
hysterics, 2006. Sent by mom Paula.

"MY CONTRACT CLEARLY STATES THAT WE ARE NOT TO BE PHOTOGRAPHED TOGETHER."

Henry Van Allen loudly protests being anywhere near anyone, including brother Collin, in this 2005 picture. Sent by mom Peggy.

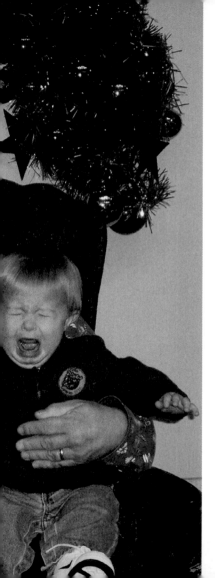

"REMEMBER, SANTA, HE'S THE NAUGHTY ONE."

Nicholas Dechert finds that you're never too young to blame your little brother, Nathan, 2005. Sent by mom Cathy.

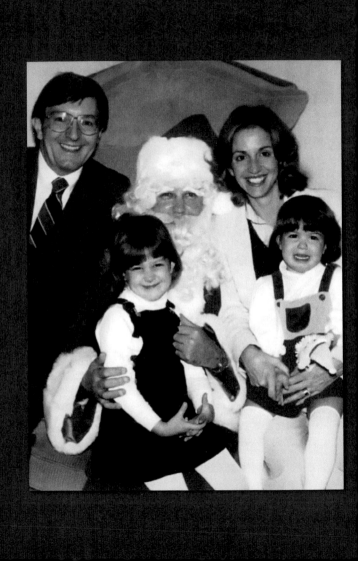

THE SEASON OF PEACE, LOVE, AND FOOTBALL.

Jack, Elena, and Renee Lynch, 1992. Sent by mom Deb.

"I'M THE BEST BECAUSE I GOT SANTA'S LAP. AND YOU DIDN'T."

Stephanie Evans sent this 1983 shot of herself savoring her big-sister superiority over Leslie, with parents Walt and Wendy.

CHANNELING CELINE DION.

Julia Proctor plays the diva to the hilt, with
brother Alex, 2004. Sent by mom Michele.

"ME? YOU CHOSE
LITTLE OL' ME AS
LITTLE MISS SNOW-
FLAKE FAIRY PRINCESS?"

Ava Babcock is not satisfied with
runner-up status to sister Ella,
2006. Sent by mom Tracy.

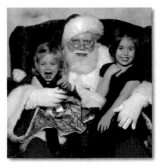

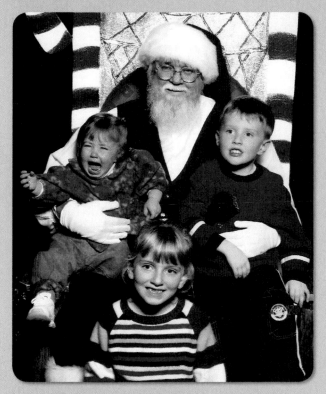

"I FIND MEDITATION CAN SMOOTH OUT THE ROUGH EDGES ALONG WITH MY SISTER'S SCREAMS."

As soon as she got a glimpse of Santa, Lia Sullivan (left) started saying, "No Santa, no Santa." She was quickly overridden by Shayla and Brendan, 2004.
Sent by parents Bill and Michelle.

THE MAN WITHOUT A FACE

How do you trust a man who looks like a cross between Grizzly Adams and Sasquatch? These overly furry Santas look more like a monster that would jump out from under your bed than a jolly old elf who comes down your chimney.

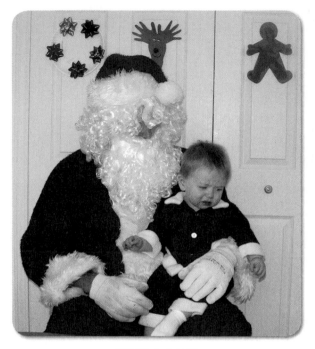

PEEK-A-<u>BOO</u>!

Ryan Bergsieker would just as soon Santa not make
house calls, 2001. Sent by parents Joe and Karyn.

NEVER MIND WHAT THE GRINCH DID, SANTA. YOU CAN'T STUFF HER UP THE CHIMNEY.

Kierstin Pendleton, 2005.
Sent by mom Stacie.

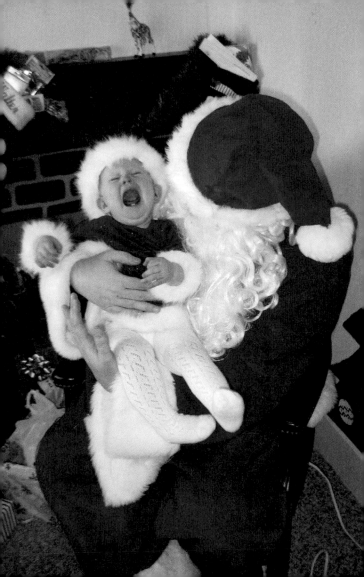

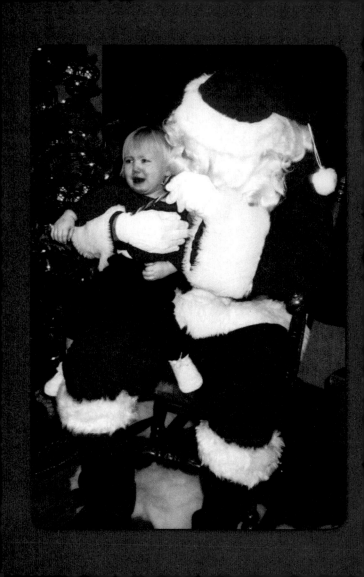

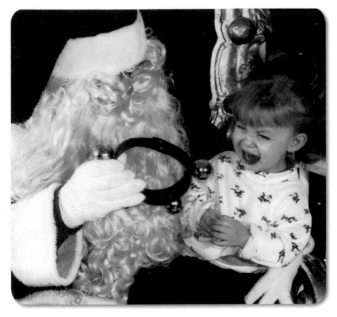

"SORRY, NO PONY. HOW ABOUT STARTING WITH A HARNESS?"

Peter Garlock reports that niece Olivia was disillusioned to learn there would be no pony under her tree, 2004.

YOU'D CRY, TOO, IF A MARSHMALLOW WITH A NOSE WAS TRYING TO STICK A CANDY CANE IN YOUR EAR.

Samantha Pryor, 2001. Sent by mom Tawna.

IF AT FIRST YOU DON'T SUCCEED, IT'S POSSIBLE YOU NEVER WILL

These sets of photos illustrate that sometimes the quest for a good picture with Santa is futile. The good news is that this failure appears to be genetic, allowing everyone in the family to share the blame.

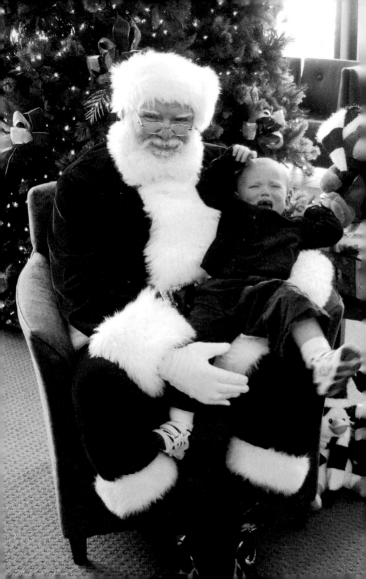

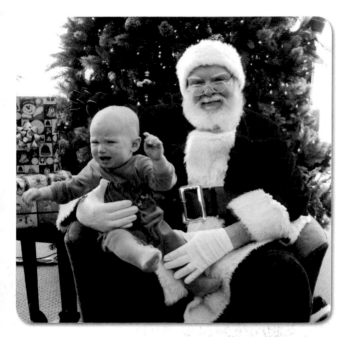

HE'S 0 FOR 2, IF YOU'RE KEEPING SCORE.

Calvin Proskey in 2005 (above) and 2006 (opposite)—
the only difference is that he grows bigger, stronger,
and more determined. Sent by aunt Lisa Corrao.

PASSING THE TORCH.

Above, Emma Peddycoart handled the crying duties the first year, then handed them off to younger sister Avery. Big sis Jordyn did the smiling and restraining. Sent by dad Brian.

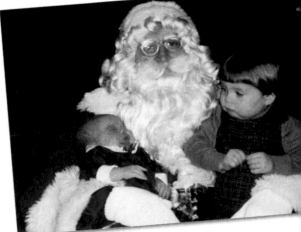

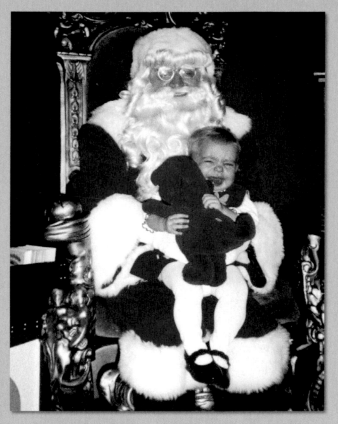

SANTA LOOKS MUCH HAPPIER WITH JUST ONE.

Nicole and Lauren Barmore (opposite), 1997, and Nicole
a year later. "Once she got away from Santa, I was able
to get a picture of her with a big smile," writes mom Vicki.

BABY STEPS, BABY STEPS . . .

Vaune Phillips progresses from tearful in 1956 (below) to apprehensive in 1957. Meanwhile, brother Duane has moved on from apprehensive to—dare we say it?—almost happy. Sent by Vaune Phillips Mondi.

ONCE A SCREAMER,
ALWAYS A SCREAMER.

William Hodges in 1997 (left)
and a year later with sister Julia.
Sent by parents Jane and Alex.

TRAGICALLY, THE FEAR-OF-SANTA TRAIT IS EASILY PASSED FROM MOTHER TO SON.

Rachel Bradley at age 2 in 1978 (left),
and her son Douglas at age 2 in 2006.

232

SCREAM TO THE LEFT, SCREAM TO THE RIGHT . . .

Taylor Shimkus in 2003 (opposite) and 2004 with a Santa we're
inviting to our next party. Sent by grandmother Sylvia Melnik.

CAN'T SANTA TAKE A HINT?

Amy Del Rio (above) in 1978, and son Nicholas
(opposite) in 2006. "He just kept saying, 'Bye-bye,
Santa, bye-bye,'" writes Amy.

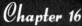

Chapter 16

HIGH
ATTITUDE

These kids are not so much scared as suspicious, appalled, or plain old ticked off after being betrayed by the people they trusted the most: the same people who are still laughing at these photos.

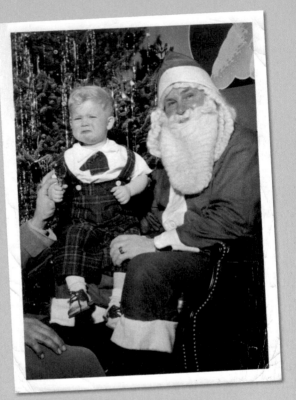

"I'M NOT SITTING ON HIS LAP AND YOU CAN'T MAKE ME! . . . WELL, YOU CAN'T MAKE ME LIKE IT!"

John Jacobson, circa 1952.
Sent by wife Rita Stevenson.

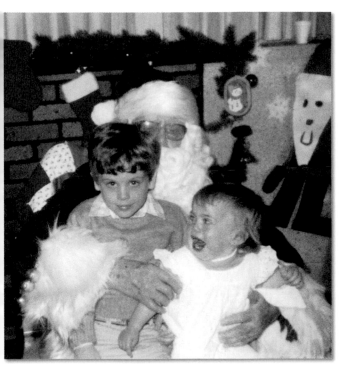

"SHE IS DEAD TO ME."

Paul Conrad has trouble distancing
himself from sister Kimberly, 1982.
Sent by dad Bill.

"NO FALSE MOVES, MISTER."

Brian Fragassi isn't about to turn his back on this
suspicious character, 2006. Sent by dad Pat.

NOT SCARED. JUST REALLY, REALLY MAD.

That's how Matthew Cotten (left) insisted that he felt over the outrage of visiting Santa, with brother Noah, 2002. Sent by mom Sue.

T MINUS 5 . . . 4 . . . 3 . . . 2 . . .

Stand back, Mom! Claire Makoviecki is about to blow, 2004. Sent by parents Tom and Marcia.

"YEAH, WELL, IT'S NO PICNIC FOR ME EITHER."

Mikaelea Zehrung, 2006. Sent by grandmother Nora Hilario.

**"HMMM . . . WHERE TO PLACE
THE STICKY FINGERS . . . ?"**

Santa may dress like a Buckeye fan, but Olivia
Johnston is still not ready to trust him, 2006.
Sent by grandma Mary Johnston.

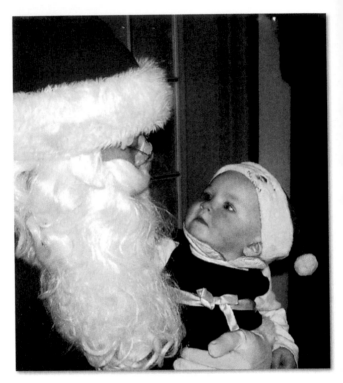

"EXCUSE ME, SIR, COULD YOU PLEASE DIRECT ME TO TOYS R US?"

Mary Grace King's interest in
Santa is strictly academic, 2005.
Sent by mom Sandra.

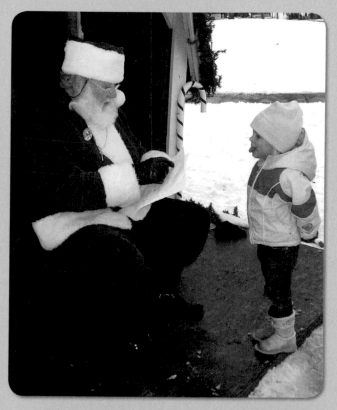

IS SHE ON THE NAUGHTY, NICE, OR NYAH LIST?

Meghan Kimberly, 2006. Sent by mom Temple.

REINDEER'S DAY OFF

Sometimes the sleigh has to go into the shop, or Rudolph schedules a promotional appearance. No problem! Santa has plenty of other ways to get around.

FIND THE SHAGGY BEAST IN THIS PICTURE.

"As far as I'm concerned," writes John Duffy, who supplied this photo, circa 1929, of his mother, Rosemarie, "this is *the* scariest/creepiest Santa I have ever seen." No arguments here, John.

JINGLE ALL THE WAY . . . TO HELL.

Patsy (left) and Diane Slager, circa 1935. "My mother recalls that the man had a red nose and alcohol on his breath," writes Patsy's daughter, Jane Rix. We're shocked. Shocked.

WHO NEEDS A SLEIGH WHEN YOU CAN HAVE A SIREN AND <u>REALLY</u> SCARE 'EM?

Believe it or not, this photo was used to promote Santa's visiting hours, according to Susan Lacaeyse. Shown are cousins Kerry Hinz Doucette, Christopher Scheuermann, and Beth Lacaeyse, 1976.

WHERE'S THE EJECTOR SEAT BUTTON?

That's Gene Trucano feeling around for a parachute or something—anything—with big sister Shirley, 1934.

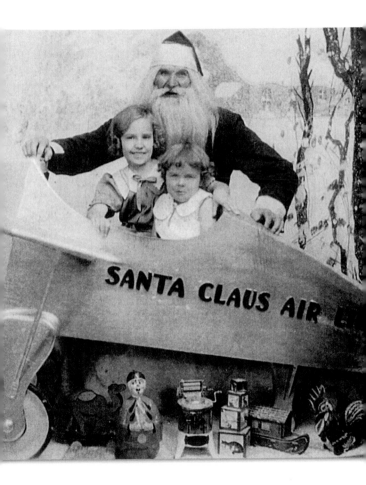

SANTA CLAUS AIR E...

Chapter 18
(DECK THE) HALL OF FAME

In its own perverse way, every Scared of Santa photo is special. But then there are the Scared of Santa photos that transcend the genre. These scenes may have a bizarre setting, or a uniquely horrified child, or an exceptionally surly Santa. But all have that certain je ne sais quoi *(translation: beats us why they're so funny, they just are)*. After studying hundreds of Santa photos, we've made our list, checked it twice, and decided that these rank at the top.

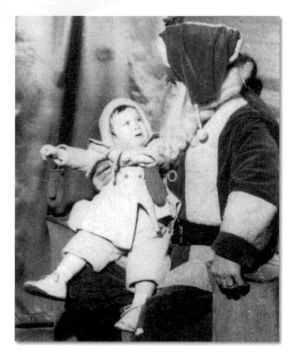

We were touched by the poignancy of
Linda Joyce's splayed limbs, the mittens
hanging mute and helpless, the terror
only she can see. Parents Tom and
Dorothy sent this scene from a
1957 horror movie.

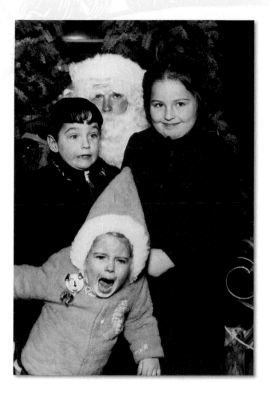

This 1969 photo has a great variety of expressions, not to mention the body English. As it turns out, writes mom Judi Hennessy, "The older children, Lisa, 7, and Todd, 5, are holding the jacket of Amy, 2, so she can't run away."

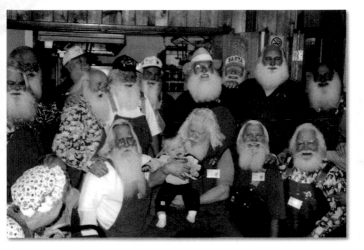

If one Santa is scary, a roomful of them is a kiddie apocalypse. Michael and Elizabeth Finn write that grandson Andrew Finn was at a Colorado church camp with his parents in 2002 when they stumbled, *Blair Witch*-like, onto a workshop for Santas.

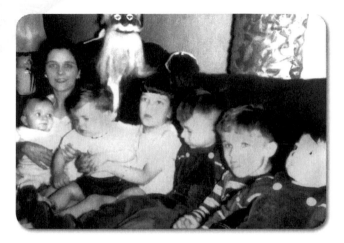

Of all the scary Santas out there—and there are plenty—the scariest of all comes to us courtesy of Roman Sikorski. Every year his grandmother's neighbor would pay them a visit dressed as some kind of minstrel-show Santa, as in this 1949 photo. "As I got older," writes Sikorski (the baby at far left), "I asked why he had to wear that scary mask. My parents explained it was to protect his face from the biting snow. . . . My cousins, brothers, and I would be so fearful waiting for his arrival."

But Roman, it's tradition!

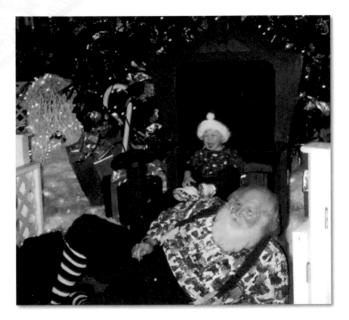

Eddie Mendrala has decided it's time for
some fresh blood at the North Pole, and he's
not even giving Santa a golden parachute,
1999. Sent by grandma Mabel Smarsh.

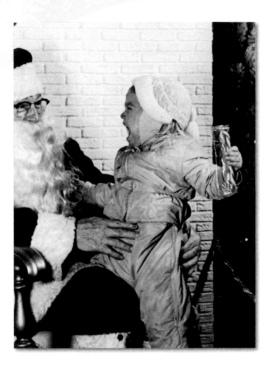

Pamela Mendrick issues a gale-force
scream without letting go of her candy
cane in this photo, circa 1965. Her mom,
Maryjane Mendrick, keeps the sibling
rivalry aflame by pointing out that
Pamela's older sister had backed
out at the last minute.

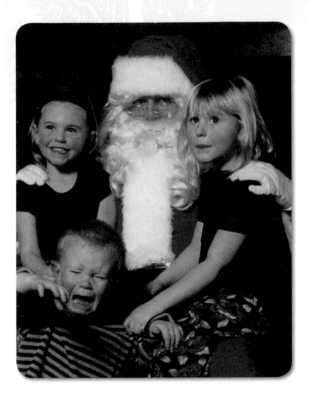

This 1999 photo has that little extra something: Is it Jarrett Vukelich's Frankenstein-like pose? The calm yet viselike grip on his shirt by sisters Erin (left) and Cat? Everyone pretending that there isn't a small nuclear device detonating right under their noses? Grandma Joan Lescher sent this with a note on paper shaped like a smiley-faced Santa (nice ironic touch, Joan).

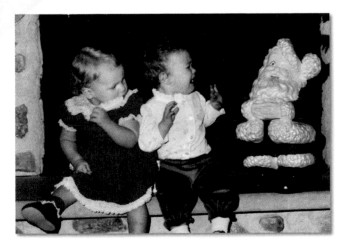

Even the Scrooges we know couldn't help but laugh at this 1981 shot from Valerie Miller, who captured daughter Amie's first glimpse of St. Nick—artfully rendered in plastic. It's the first in a series that Miller says she torments Amie with every year. Now *this* is a mom who knows what Christmas is all about.

Chapter 19

YES, VIRGINIA,
HE'LL BE BACK

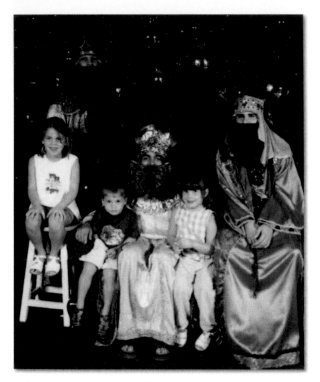

WHEN SANTA'S EXHAUSTED, HE PULLS CASPAR, MELCHIOR, AND BALTHASAR OFF THE BENCH.

Olivia, Austin, and Claudia Beard don't seem to mind
the second stringers, 2000. Mom Lourdes reveals that
"the three 'wise' men are each about 8 years old.
They are more like the three wise guys."

"DOUBLE ESPRESSOS, EH? SO THAT'S HOW HE DOES IT ALL IN ONE NIGHT."

Kyle O'Shaughnessy, 2002. Sent by mom Cathy.

Acknowledgments

THANKS to the *Chicago Tribune*—and the parents and grandparents and aunts and uncles—for making the photos available to us, and to our colleagues, especially Paul Iwanaga, Laura Moran, Ben Estes, and Rick Kogan. Thanks to Pat Crowley and Jan Tuckwood of the *Palm Beach Post*, who did a "Scared of Santa" feature first and generously shared the idea.

Thanks to our editor, Sarah Durand, for loving these pictures as much as we do, and our agent, Dan Lazar, for finding us.

Denise is grateful for the gift of Amanda and Jonathan and for Christmas memories that hold much more laughter than weeping. She sends a special thanks to her mom and siblings Sharon, Brad, Jacki, and Cindy, who understood why e-mails and phone calls went unanswered for long stretches—and accepted her excuse for not making it to the annual Testicle Festival. To her best friend, Joe, she says it's sweet that he admitted being a bit jealous of Santa.

Nancy is grateful to Griffin for patience above and beyond what anyone can ask of a middle-schooler, to Mom and Dad for the wisenheimer gene and the unceasing support and love, and to Brian for knowing that deadlines are temporary but other things are not.